3 56 W9-AFN-091

Chase Branch Library
17731 W. Seven Mile Rd.
Detroit, MI 48235

MAR 08

CH

Connecting the Dots

A PAINTED TURTLE BOOK — DETROIT, MICHIGAN

CONNECTI

Tyree Guyton's Heidelberg Project

G THE DOTS

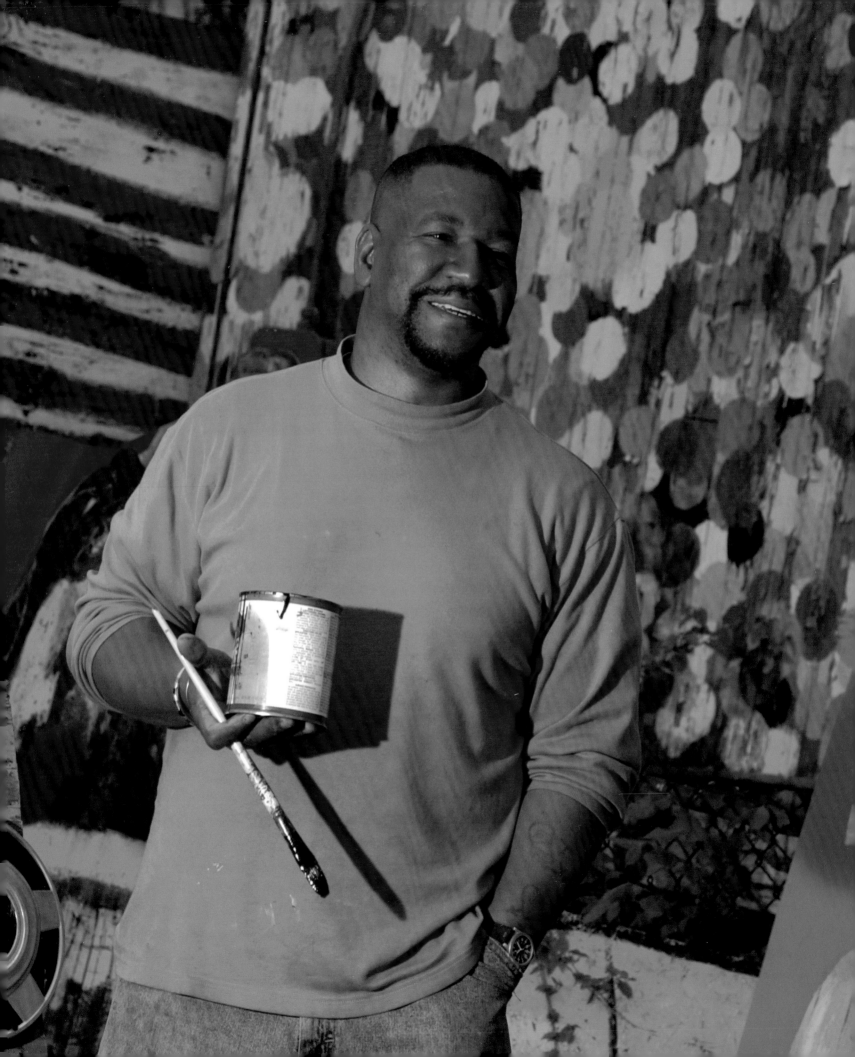

FROM THE ARTIST

Today, in 2006, as I look back, my art, the message, the ideology have brought me to this point. Twenty years of using art as a symbol of life and current issues; twenty years of contending with the inconsistencies and hypocrisy of government; a time of war, chaos, catastrophic events, and the breakdown of the human spirit.

I strive to be part of the solution. I see and understand how order is needed in the world and in our individual lives. My experiences have granted me knowledge about how to create art and how to see beauty in everything that exists.

Even in the smallest things in this life, we are all bound by the same energy; we are all bound by gravity and we breathe the same air. I can see the evolution of life in everything, in every second. How beautiful it is to witness this process in action. What is beyond space, and can we possibly look that far into ourselves?

What is art? I ask myself this question over and over. Is my life an art form? I began to see and hear my own work in a new way; it opened up my third eye of wisdom and my mind

Guyton at work, 2003. DONNA TEREK. to how everything is connected to this one source of energy, or this divine power. I believe that it will take a lifetime for me to understand it. I find my art to be just like that power. It creates energy in a negative space. This energy becomes my focal point.

Right from the beginning of time, life has changed from one state of existence to another. This evolution keeps the world turning. Consequently, my work is always changing to reflect the evolution of humanity. The Supreme Being is the energy source that gives humans and all earthly creatures life, and I believe my job is to create life on the canvas. This change, or metamorphosis, is both good and bad energy, negative and positive energy, all of which helps me to find balance in my work and my life. My work is radical and extreme. It's not

about right or wrong or aesthetics. Instead, it asks, Can it work in the space, at that time? Taking the detritus, or discards, of life and allowing the elements to participate in the creative process is how I give life back to the canvas.

I believe that I was called by the Heavenly Father to go beyond and explore the unseen. What was revealed to me was true magic beyond my human intellect. I didn't understand it nor was I able to process it. I went from the canvas to something that changed the way I see everything.

I always believed that I was different from the rest of the world and spent a great deal of time daydreaming. When I was five or six, my great-grandmother, Kate Reese, would tell me, over and over, that I was chosen to do something special. School didn't interest me much, and neither did hanging out in the streets, as it did many of my friends and brothers.

In 1964, when I was nine, my Grandpa Mackey gave me a paintbrush and told me to paint the world. Grandpa Mackey was my mentor and my best friend. He also told me that he could see the wind blow, which I would come to understand much later in my life. There was a time, growing up in the '60s, when it felt like hell—a time of total chaos between blacks and whites, the murders of those fighting for equal rights, the black power movement, the Vietnam War, and the riots of 1967 in Detroit and elsewhere. Detroit, our great city, has been burning ever since, and so have the people.

At sixteen I dropped out of school and headed to the army. After I came home, I held jobs with the Detroit Fire Department and with Ford Motor Company, but the dream of doing something great never left my mind. In 1980 I went back for my high school diploma and eventually enrolled in art school at the College for Creative Studies in Detroit. One of my instructors—the renowned Detroit artist Charles McGee—made a lasting impression on me. Charles told me that I should explore deeper with my art and that there was more in me than beautiful landscapes.

In 1986 I took my art to the streets of Detroit. The community where I grew up had become characterized by drugs, crime, prostitution, and gangs. I watched, in horror, the deterioration of my neighborhood. With the help of my then-wife, Karen, and Grandpa Mackey, I set out on a mission to change my environment. I used what was available, and so

it was from the debris of the neighborhood that I created the Heidelberg Project landscape. There was no plan and no blueprint, just the will and determination to see beauty in the refuse. My work became controversial, but it was also a medicine for the people.

Government and religion have created a nebulous situation in the minds of people, not just in Detroit but all over the world. Our government is not really "for the people, by the people"; our government is for the rich. Our government is full of contradictions and hypocrisy, and as a result people are sick and dying. Many of these messages were (and still are) found in my art. However, it was difficult for government, and, consequently, for people, to understand my message of hope in this new type of composition.

The word *compose,* according to the first definition given in *Merriam-Webster's Collegiate Dictionary,* means "to form by putting together." I have come to the realization that I have been called to create art that is unusual and compositional in form. The traditional and conventional way is a thing of the past. We live in a world full of corruption from top to bottom, values no longer exist, and rules are broken every day. For me art is a way of expressing life.

Through the process of composition my understanding has become more profound and created for me a new hope and a new beginning; I can venture off into space and find myself traveling into the unknown of my subconscious mind. Again, my work asks questions and creates a dialogue that reflects life and tells a story—my story, your story—about life and what I see in the world.

Now I come to a point where I am able to hear my work through this essay as I write, and what I hear is rhythm, harmony, and unity all coming together like a great symphony or like a great sexual experience, one that takes place in the mind. I create beauty—my own beauty from what I see, what I understand, but not without being able to first relate to the beauty in myself.

As I live each day, I learn something new about life, so the past, the present, and the future become this new energy, and this energy consists of colors, textures, the wind, the rain, the snow, and found objects. Yes, at times it doesn't make sense, just like life, but through it all there is order. Tomorrow will bring a new day, with new experiences that are inexplicable to the heart and soul, but, eventually, it will also come into order. ●

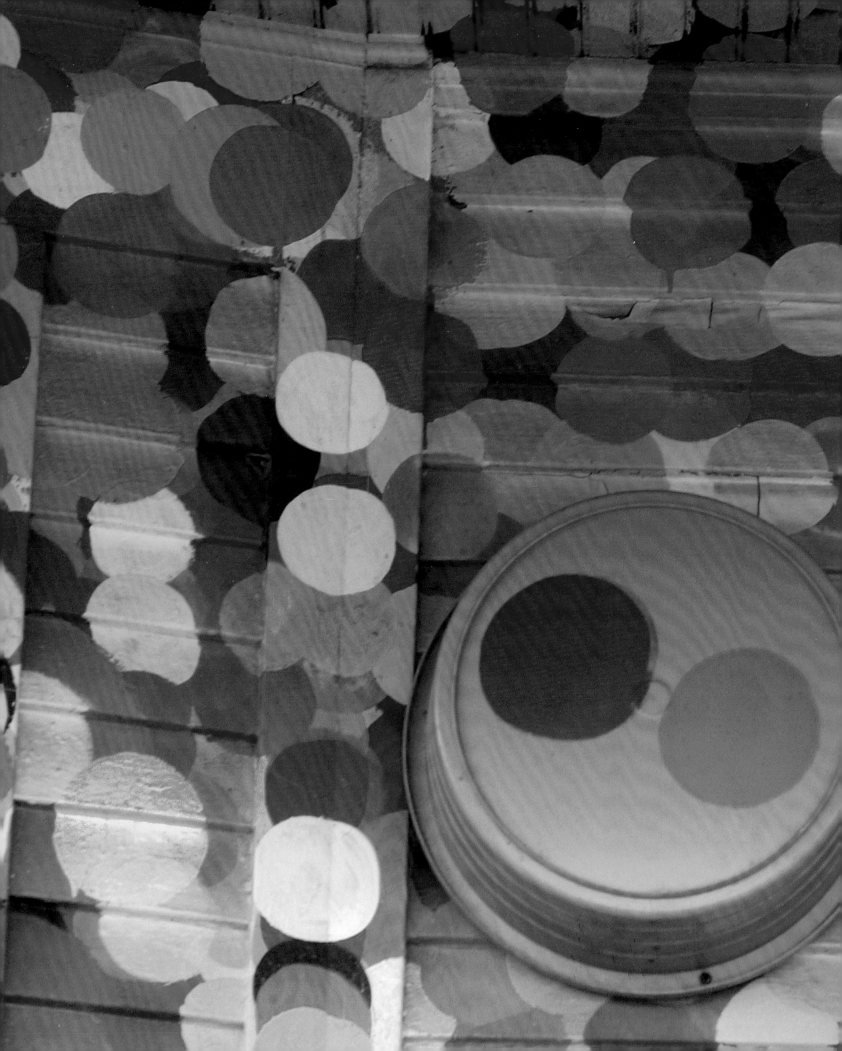

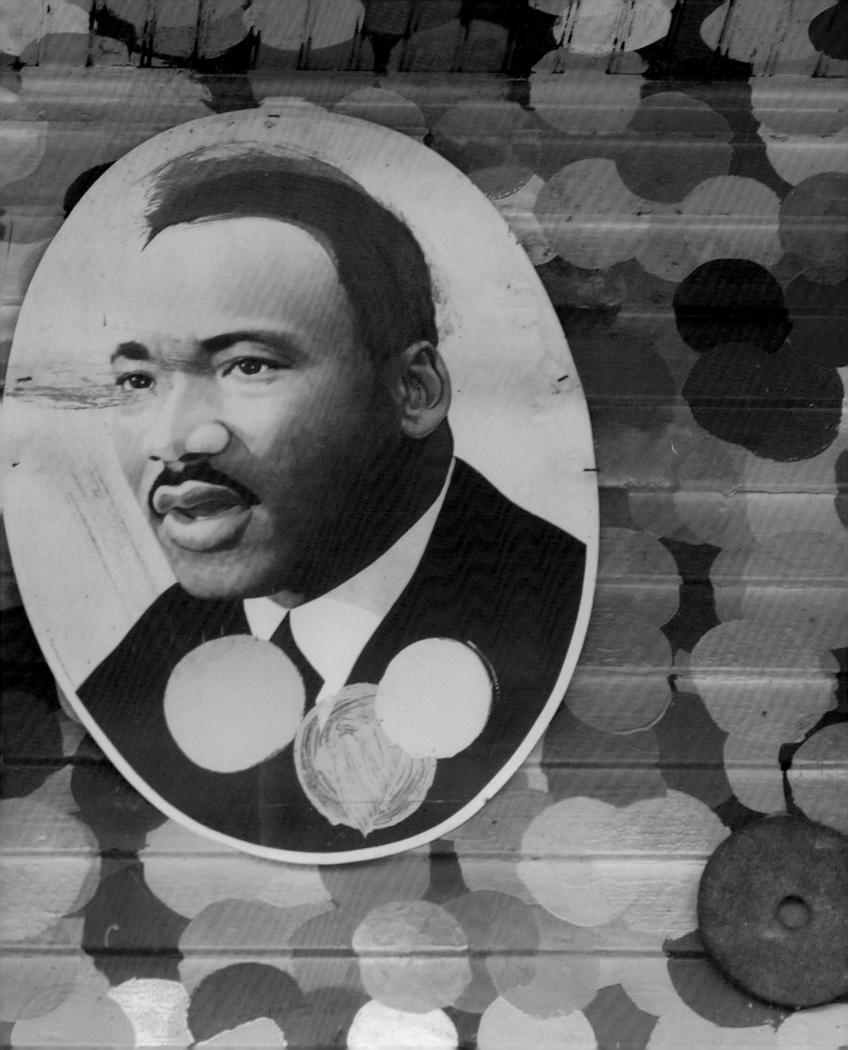

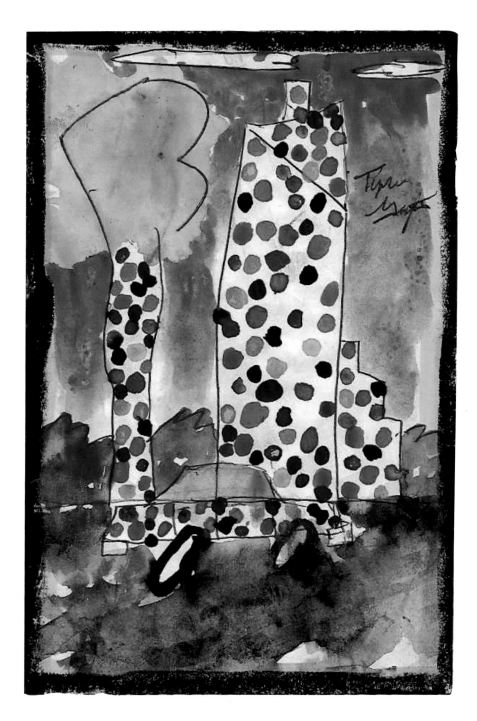

GETTING TO THE HEIDELBERG PROJECT

ON THE 201ST ANNIVERSARY OF THE GREAT FIRE OF 1805, OR MANIFESTO FOR A NEW DETROIT

How do you get to the Heidelberg Project? It's a plain enough question and ought to be easy to answer. Google will get you there—just click on the link and a map appears, with that short little street highlighted, the one where Tyree Guyton launched his art project twenty years ago. So you get in your car and head out, drive around Heidelberg Street, surveying all the improbable stuff that Guyton has assembled—on houses and trees, on empty lots, and maybe even in the street itself. Have you gotten to the project? Well, you've certainly found what's left of it, following two demolitions, when the city tried to take apart all that Guyton and his grandfather Sam had spent years putting together. And there's still plenty left to see. But is that really the project?

Watercolor study for Dotty Wotty House and Dotty Wotty Car, 8 x 5 in., 1994. HEIDELBERG ARCHIVES.

I'd say no, that's not the project, or at least what you see is not all of the project, maybe not even the most interesting or important part of it. The "project" is a lot more complicated than what's there on the ground, and it takes more to get there than just a visit in your car or on foot.

Start with Neal Shine's beautiful little reminiscence about the late Sam Mackey, Guyton's grandfather, with Shine and Mackey sitting together on Sam's park bench, sharing an orange, talking about life. It was Sam who—as Guyton tells it—put a paintbrush in the

nine-year-old boy's hand and told him "to paint the world." Which Guyton did, of course, to such memorable effect. Grandpa Sam is certainly part of the project, crucially so. And if you don't get to know Sam, have you really known the project?

Not that the project is all about gentle reminiscing and ghosts. Far from it. It is also a mare's nest of legal troubles. "From an attorney's perspective," as Daniel S. Hoops puts it in his essay, "the Heidelberg Project is a legal miasma that invokes strategies and concepts sometimes as thought provoking as the art itself." Hoops is a lawyer, so he ought to know. This is not to make any less of the art, only to say that it's not all there is to the project, and if you miss out on the fights—legal and otherwise—some of them right there on Heidelberg Street—well, that would be like walking across a great battlefield, unaware that it is hallowed ground.

But the Heidelberg Project is not just about lawyers and wrecking crews, and reporters and cameramen jockeying for their obligatory soundbites before the bulldozers do their worst. There are careers wrapped up here, and good intentions gone to waste, and politicians, of course, as Marilyn Wheaton will tell you. She's a former director of Detroit's Cultural Affairs Department, who saw things go from honorific to smash, with Guyton being presented a Spirit of Detroit Award by the city council in 1989. Two years later he was named a Michiganian of the Year by the *Detroit News*—the same year Mayor Coleman Young undertook the first of the Heidelberg demolitions. After the second demolition in 1999, Wheaton's mother asked her, "Why would they do that?" Marilyn responded, "It's politics." If you don't know all the politics that Heidelberg provoked and that Wheaton fills in so usefully, you really haven't known the project.

Not that all politics are evil. On the contrary, the politics lend power and relevance to all that has been done—and undone—on Heidelberg Street. "Art or Eyesore?" as John Beardsley so succinctly states the question in his essay, noting that "the kind of spontaneous, unsanctioned art created by the likes of Tyree Guyton typically has several audiences, often with distinctly different views." A nicely understated point that sets the stage for his discussion of what is behind the frequent conflicts on Heidelberg Street, conflicts pitting neighbor against neighbor, city residents and government officials against suburban visitors, as issues

of class and race—never far from the surface here in Detroit—have come to dominate and often disrupt the debate about Guyton's achievements.

So if you want to visit the project, you'll need to engage that contentious question of art and whether people ought to be made to live next door to somebody else's idea of beauty. Marion Jackson, who is an art historian, does a fine job telling Guyton's story, putting him and his work in context—in several different artistic contexts, as a matter of fact, because not just one context will suffice: "One can wonder why the Heidelberg Project has catalyzed so much controversy, especially around the question of art versus trash." That "wonder" is in fact a crucial element of Guyton's achievement—that he can raise profound questions about art and life using only the "junk" his neighborhood provides. And it's wonderful that he can inhabit so provocatively the conflicted terrain where art becomes something else, "an interactive social process," as Jackson puts it.

It's exactly this interactive social process that has gotten Guyton into the news and also into trouble with some of his neighbors, who play a crucial role in the project, both for and against. Michael Hodges, who is a reporter for the *Detroit News,* has done a brilliant job bringing the whole neighborhood in—those who love the project and those who want it demolished. Hodges raises maybe the toughest question of all: "With the clear majority of neighbors either indifferent or hostile, what claim can Heidelberg make to community enrichment, a central part of its professed mission?" You'll hear folks talking both sides of the question in Hodges's essay, having their say about the enthusiasm of absentee admirers such as Aku Kadogo, a resident of Australia, who visited the project in 1996 and became immediately subject to its power, which she describes in her essay: "What I saw on Heidelberg Street was beautiful, chaotic order. What I discovered was that a citizen of the world had taken matters into his own hands to induce dialogue, to make people shout with joy or anger, to dare to *think*. Welcome to the world of Tyree Guyton!"

Which returns things to the vexed question that Michael Hodges poses and then lets the people in Guyton's neighborhood answer for themselves: "Is the local community of mostly ticked-off neighbors being sacrificed to a higher good? Is their annoyance and sense of dispossession balanced by the advances, however shallow or halting, that some white visitors

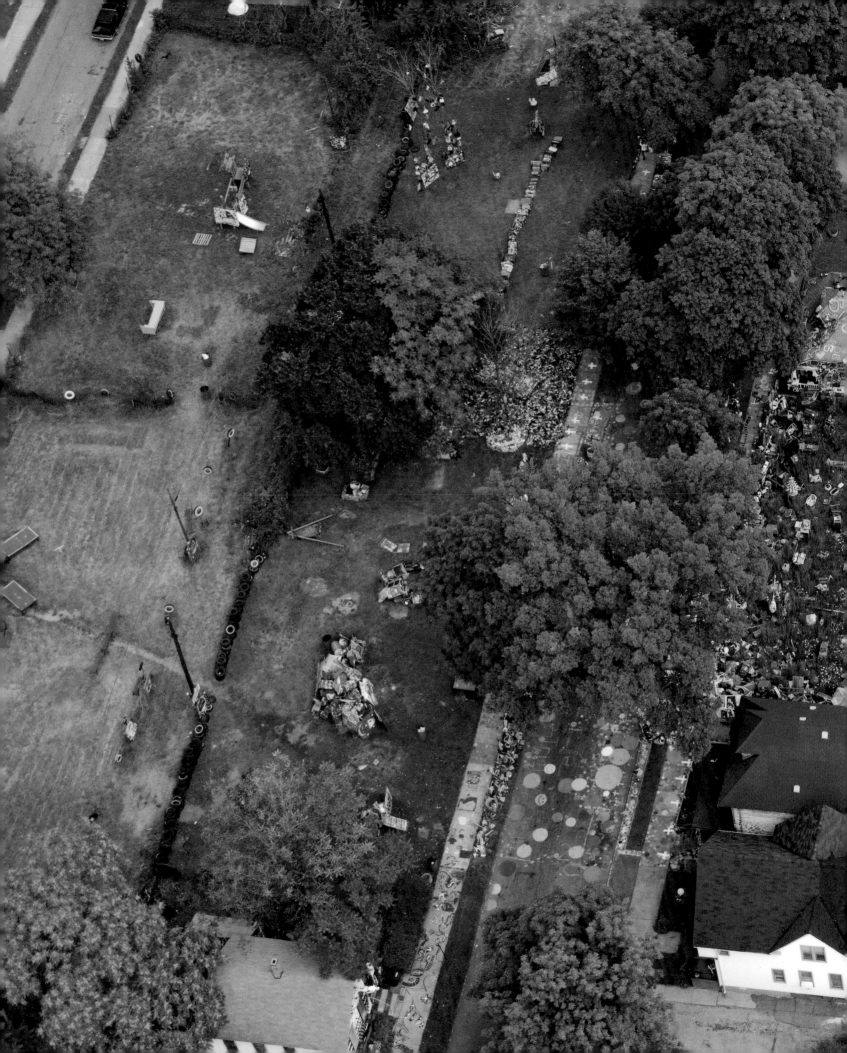

might be in the process of making?" Who gets to say if it's a good day in the neighborhood? Is it the neighbors or somebody else? Hodges doesn't try to force an answer; he just lets the people argue, because there's not going to be an answer that pleases everybody. That's part of the project too: it is so constructed—physically, artistically, politically, legally—that its power consists in its built-in perpetual undoing.

After all that has raged in and around Heidelberg, it's a pleasure to come to the final piece in this collection, by Jenenne Whitfield, who starts out as a visitor to Heidelberg and ends up an official part of it, as well as married to Tyree Guyton. Hers, then, is the ultimate inside view, as she has titled her essay. She gets you inside the project and the neighborhood, and also inside the man who has created Heidelberg: "What I learned about the man, his art, his vision, and his life was so amazing that I began taping our conversations. I learned about Guyton's family life and his passion for art, which was inspired by his grandfather. I learned about his children, his failing marriage, and three brothers who had died on the streets. I learned about the demolition of his work in 1991 and how he had vowed to continue. Guyton also helped me to discover beauty in the simple things of life."

While that is where the essays end, it's hardly where the project ends. After all, this project is a whole lot of things all at once—legal tangles and art-historical squabbles, neighborhood battles and demolitions, spiritual journeys and catfights, "art" maybe, and life, surely life, that this project forces to an intensity that, regardless of one's view, is impossible not to admire. That's the conflicted route, maybe the only route, that will really get you to Heidelberg Street.

That's the route I have traveled to arrive here. I am marking this day on Heidelberg Street, June 11, 2006, for a reason: it's 201 years since the great fire that engulfed Detroit. Individual catastrophe aside, the fire yielded two important outcomes for the city, though *city* seems much too grand a word for the shabby frontier outpost of five hundred souls that had just burned to the ground. In 1805 Detroit consisted of about a hundred wooden structures, none in a very grand state of repair, all reduced to cinders within three hours' time on that windless Tuesday morning. The fire brigade made a futile attempt at putting the blaze out, but their one pump failed almost immediately, and buckets proved insufficient to the task.

As I said, there were two immediate results for the city. The first had to do with planning. Thanks to the fire, the center of town could now be relocated, outside the narrow confines of the old French stockade. In the process, Detroit's boundaries were also expanded significantly, and for the first time a real city plan was drawn up. That was the work of Judge Augustus Brevoort Woodward, a personal friend of Thomas Jefferson's and a great admirer of Charles L'Enfant's layout for the national capital in Washington, D.C. So Woodward modeled his plan for Detroit after L'Enfant's. Woodward's vision was grand. The eccentric judge imagined a great metropolis of fifty thousand residents, one hundred times the population recently displaced by the fire. His city would be defined by vast boulevards running north to south and east to west, each two hundred feet wide. These would periodically intersect at large plazas, or "circuses," which would be further connected by a secondary system of avenues 120 feet wide and radiating from circus to circus at oblique angles, like the spokes of a giant wheel. Improbable, sure, but the plan was adopted in 1807.

Some proposed boulevards and avenues were actually laid out, and half of one circus got built (the Grand Circus Park, as it was called, even though it's only a semicircus) at a site so far out in the country two hundred years ago that nobody gave much thought to the scale of Woodward's grandiloquence. But that would soon change. In 1818 Detroit abruptly abandoned the Woodward Plan, because the city had begun to grow—a lot: its population would quadruple by 1830. Woodward's plan just seemed like too much trouble. His complex, intersecting street system required both forethought and considerable expense if it was to be carried out consistently. Failing to see the point, citizens traded Woodward's idealized metropolis for a workmanlike grid that required no forethought whatsoever to reproduce.

The second result from the fire goes a long way toward explaining why we have so carelessly humiliated Woodward's grand ideals. Walking through the cinders of Detroit on that day in 1805, the preeminent local priest Father Gabriel Richard was overheard to say, as if to himself, a phrase that became—and remains—the city motto: *Speramus meliora; resurget cineribus*. We hope for better things; it will rise from its ashes. Richard's musing has turned out to be ironically prophetic. We are forever laying waste to the past, each time in the hope that something better will arise. Which leads to results no rational person would have chosen

or can easily defend. Start with the way our city streets are arrayed. Roads preserved from the old French town intersect Woodward's grandiose scheme at odd angles. Then the Woodward streets haphazardly give way, in turn, to the mid–nineteenth century urban grid that in the 1950s would be overlaid by yet another system, this time of sunken freeway ditches and ramps. Afterward, in the years following the riots of the 1960s—when, as then-mayor Young put it, "half the goddam population left"—Detroit began to be overtaken by an expanding urban prairie, as if nature is returning the city to a preplanned state. Not just roads and vacant lots and abandoned buildings are at stake; so are people's lives, and all that has been laid waste in this city, and left behind, in the hope that something better will arise.

What to make of it all? *Speramus meliora; resurget cineribus*. Hope and destruction forever linked. Our optimism is founded on a spectacle of ruination. Which brings me back to Heidelberg, a particularly apt spot to be recollecting the great fire and contemplating the future of Detroit. If there is to be a future here, it can be founded only on a full understanding of what has come before and of what we have made of the past and each other. It's probably not a matter as simple as storytelling, or not *only* that, but of something more complex and overwritten—something like the successive acts of hope and destruction overlaid on Heidelberg Street.

The project seems tamer now than the Heidelberg I remember from fifteen or twenty years ago, the one preserved—invaluably—in Harvey Ovshinsky's film *The Voodoo Man of Heidelberg Street* (1990). Some houses have been demolished, and things appear softer and a lot less scary looking—not as many dismembered baby dolls and weird assemblages. Now there are stuffed animals and all the cartoon-painted car hoods. The project has an orderliness about it that is more inviting and planned in its aspect. Which doesn't mean it is any less powerful but only that it is different, that it has changed. The changes provoke all sorts of recollections, so that, sitting here, the project is not so much just what I can see but what I can remember seeing and hearing. Heidelberg becomes a kind of palimpsest, a figure overwritten by successive acts of memory and destruction, where hope and bulldozers, art and demolition pile on, layer upon layer. *Speramus meliora.*

I can see Sam Mackey sitting across from me and hear children laughing. I remember

standing in line, *right over there,* waiting my turn to deliver a soundbite to the network news crews, while tourists picked through the rubble of the latest city-orchestrated demolition. *Resurgit cineribus.* Then I went down to the courthouse, taking my spot on a hard bench with the other assembled experts, ready to speak my piece on behalf of art. A passerby asked if I would want Guyton's house next to my own. And I answered the question, although I've had time now to contemplate the honesty of my reply (Yes, of course!), which I offered then in a state of anger and frustration—the same anger and frustration I have often felt while living here for twenty-four years—at the squandering and stupidity, the careless disregard for this place that all of us who live in it and around it share, maybe the only thing we share.

If you believe the statistics, a half or third or more of the people who call Detroit home say they'd leave if they could. And no wonder, with all that is old and sick and tired and abandoned here, so that wasting becomes the poor man's conspicuous consumption. But that's not all of it, either, because this is also a place that keeps on getting at people's hearts so they can't bear to leave, even those who can afford to, or maybe have left, but who feel compelled in memory to keep coming back home, not always understanding why, or even wanting to, a little angry and confused, perhaps, or sentimental and full of blame ("Look what they've done to my town!"). But they are drawn: by what we were and what we could be and by the shared heartbreak at all that keeps us from embracing the possibility of what we might become. *Speramus meliora; resurgit cineribus.*

If this place is to have a future, we will need a manifesto, something to get us—all of us—up on our feet, maybe not all believing the same thing but at least all up in arms and doing something, if not together precisely, at least converging on a common site, so that the heroism and stupidity, sacrifice and wasting that is our history together isn't reduced to ashes yet again. That's when I realize that we *have* our manifesto if we'll only bother to read it, and our manifesto of course is this overwritten project called Heidelberg. ●

Jerry Herron is a professor of English and the director of the Honor's Program at Wayne State University. His publications include *Afterculture: Detroit and the Humiliation of History.*

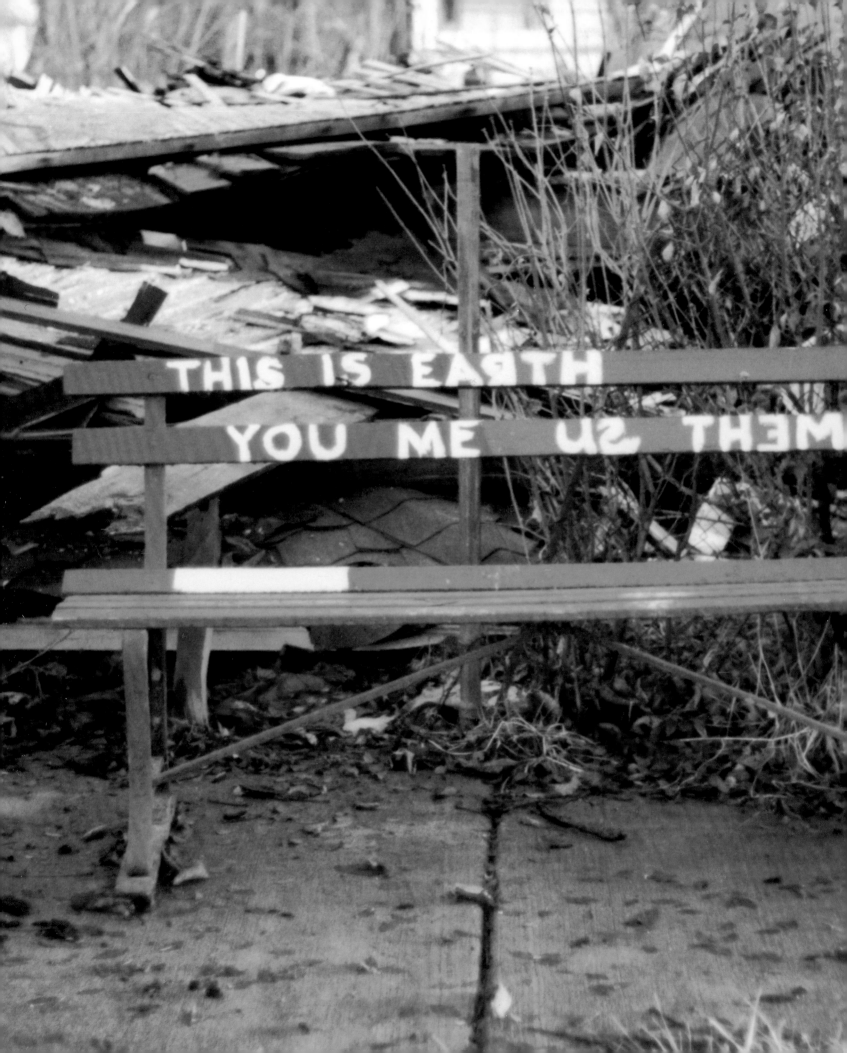

REMEMBERING SAM MACKEY

NEAL SHINE

If the weather was good, so were the chances that Sam would be sitting on the green park bench in front of his house, looking across Heidelberg Street at the joyous clutter that his grandson Tyree Guyton had created. Actually, Sam was part of it all: his heart was part of the inspiration, his eye was part of the artistic creation, and his hands were part of the hard work.

If the bench was empty, I would park my car in front of the house at 3658 Heidelberg and sit on the bench and wait for him. It was never long before Sam Mackey would come out of his house and sit next to me.

I was writing a column for the *Detroit Free Press* in those years, and one of the most appealing aspects of that assignment was not being required to spend all my time behind a desk. I had no office hours, just deadlines. To be honest, things going on outside the Free Press Building were infinitely more interesting than what was happening inside, so I spent as much time as I could outside. Stopping by Heidelberg Street was always near the top of my list.

Exactly when I saw the Heidelberg Project for the first time is no longer clear to me. I remember going there sometime in the mid-1980s with Peter Gavrilovich, a colleague and editor at the *Free Press,* to discuss including it—which we did—on the orientation tour of Detroit that we conducted regularly for new staff members of the *Free Press*. Gavrilovich was surprised that I had not already visited the project.

We had just turned west off Mt. Elliott onto Heidelberg when I saw the house, an abandoned derelict like hundreds of others in the city. They stood, as they do now, empty and in various stages of decay, waiting to be pulled down by the city per some unworkable bureaucratic timetable, waiting for scavengers to strip them of anything worth selling and then for vandals to set them on fire. They were places forgotten by all but the people who had to look at them every day.

The empty house was next door to Sam Mackey's home. Abandoned by the families whose walls it once sheltered and written off by absentee owners who never had the emotional stake in the place that its tenants did, it would end its days sliding slowly toward an inevitable and undignified fate.

But something had happened to the old house. There it stood, adorned with a city's

castoffs—street signs, battered toys, suitcases, bedsprings, auto parts, crutches, kitchen sinks, tires, broken dolls, tennis shoes, wigs, downspouts, toilets, typewriters, an iron coffin, and a phone booth. It had been given a new life. Not the life it once had but a new life nonetheless. Once again it was part of something important, brought to life by someone who found life and beauty in what the rest of us saw only as trash.

I met Sam that day. He was standing quietly at his grandson's side in front of the old house made new again. If he was trying to disguise his abundant pride at what Tyree Guyton had created, he was not terribly successful. Sam smiled broadly when Guyton introduced him to Peter and me, telling us, "And this is my grandpa, Sam Mackey."

In the years that followed that first meeting, not many weeks passed that I did not spend part of a day sitting on the old bench, talking some with Sam but listening even more. He told me he was born in St. Louis in 1897. Well, not exactly in St. Louis, he added, but *near* St. Louis. He said he came to Detroit in 1918 and described his trade to me as a painter and decorator. I remember deciding that the prodigious amounts of paint that spattered his brown jacket were testament to the truth of at least half that description.

If he had an orange in his pocket, which was most of the time, he would share it with me while I listened. He talked about his life, his city, and a world he knew more about than many of those who had seen much more of it than he ever did. The days I spent sitting with him on the old green bench are times I still cherish. I never came away from a conversation with Sam without understanding some things more clearly than I had before we talked. One thing I learned was that he had a wry, understated sense of humor, something that was easy to miss if you were not paying close attention.

I asked him one day where the green bench had come from. I told him it looked a lot like the benches found in all the city parks. He told me the bench was just there and, as best he could remember, had always been there. I told him that on the back of the bench, barely legible under successive layers of dark green paint, you could still make out the words "Dept. of Parks and Boulevards." I asked him if he knew what that meant. He thought for a minute, shrugged, and said, with only the slightest trace of a smile: "I don't know. Maybe this used to be a park."

Sam would have vigorously resisted being called a philosopher or even a very wise man. He maintained that wisdom was not something that came from living a long time. It came, he said, simply from paying attention to the things happening around you. Long life or short life is not what matters, he said. What's important are the lessons to be learned every day, some small and some large. All you have to do is be ready to learn them and then not forget what you learn.

He had some wisdom about old houses as well. He told me the problem with people was that when they looked at an old, broken-down house, all they saw was an old, broken-down house: a pile of broken bricks, weathered boards, torn shingles, and empty windows

PEOPLE THROW THINGS CAN'T SEE THE BEAUTY

blocked with plywood. It was, he said, a lot like the way some people looked at old folks—seeing nothing but the outside and not what was really important.

There was life in those houses once, he said. People just see what's left and forget about the families who lived there; they forget that there was love inside those walls, a place where children laughed and babies were born and where people got old and died. Not just a bunch of old sticks. Maybe there was pain and sadness in them too, but that also was a part of living.

I told him once about something called "psychic echoes." I told him I believed that there were echoes from the past in places like old houses, in the walls, in the floors, and in the ceilings. They were, I explained, the voices and sounds left behind, and you could hear them if you listened hard enough and honestly believed that the place could speak to you. He told me he knew about all that before I was even born. I believed him.

It was always clear that spring was the season he cherished most. He saw in spring's rebirth a renewal of life for all living things, even people. It was a season for hoping, he said. One spring afternoon, as we talked about the green just beginning to color the leaves of the

trees on Heidelberg and the joy of the season, I recited a scrap of poetry, one of the hundreds of verses that still rattle around in my head:

In the spring a livelier iris changes on the burnish'd dove;
In the spring a young man's fancy lightly turns to thoughts of love.

He asked me who wrote that and I told him Tennyson. He asked me if I knew how old the poet was when he wrote it. I told him I didn't know but that Tennyson was in his eighties when he died and might have written it late in life. Then Sam said it didn't really matter

AWAY WHEN THEY IN THEM ANYMORE.

because, as far as he was concerned, there were no age restrictions on thoughts of love. He then asked me to write it down for him. I wrote the lines in my notebook, printed TENNYSON under it, and tore out the page and handed it to him. He folded it, put it in his pocket, and asked me to say the words again. When I finished he said, "I like that man."

I no longer remember how the subject of friendship came up one day, but Sam was talking about it. He told me that friendship, if it was deep enough and lasting, was sufficient on its own to bind people together. Nothing else was or should be necessary to remind someone of another's friendship. I remember his telling me once that when a man buys flowers for a lady in the hope that she will forgive him for doing her wrong, he is wasting his money. Giving her the flowers will just remind her again of what you did to hurt her and will make her even unhappier. Give her flowers, he said, for no reason at all. Not her birthday, not Valentine's Day, not Sweetest Day or, as he called it, "Sweethearts' Day." Every lady likes to be surprised, he said.

The day we talked about friendship, he said that although a gift from a friend is never necessary, it is certainly proper.

Then he went inside the house where he had lived for nearly fifty years and returned with a picture he had drawn. It was a signed crayon drawing, an angular portrait of a woman, the gender determination made possible by the two circles on the subject's chest with a dot appropriately centered in each circle. It was in a heavy wooden frame that he had painted dark red. When he handed it to me, he said he would always be my friend and that the picture would simply be a reminder of that friendship.

I hung the drawing on my office wall at the *Free Press,* next to a black-and-white photograph taken by *Free Press* photographer Steve Nickerson of Sam when he was ninety-two. In the picture Sam, serious and Guyton, Mackey, and Guyton's former wife, Karen. 1988. HEIDELBERG ARCHIVES. unsmiling, is resting his head wearily on his right hand. There is more than a little nobility in the portrait. Sam's face is lined and creased, carrying every year. It's as though he is trying to remind us that life, never an easy journey, is more difficult for some than for others.

It is, in a way, how I remember him, serious and thoughtful, except for those moments when he saw subtle or ironic humor in situations or when he was talking about his grandson. He always made sure that people admiring Guyton's work understood that it was he who gave Guyton his first instruction in painting. Sam had been a housepainter, and as soon as Guyton was old enough to grip the handle, his grandfather put a brush in the boy's hand and set him to work.

In a 1989 *Detroit Magazine* interview Guyton said, "Grandpa was always in the picture, because he felt I had something inside of me that I wanted to say. Grandpa was a commercial painter and he would take me with him, and I would help out. He was a person I could always talk to and go to. He would pay attention. I didn't have a father, so he's always been a big part of my life."

Guyton recalled the first time his grandfather handed him a paintbrush. "It was like magic," he remembered. "It was like bells went off in my head. My hand was burning. I knew then that I was put here to be an artist."

Guyton was nine.

In that same article, Sam referred to the younger generation, the youngsters who were always prominent among the visitors to the Heidelberg Project, as "weaker and wiser." He felt

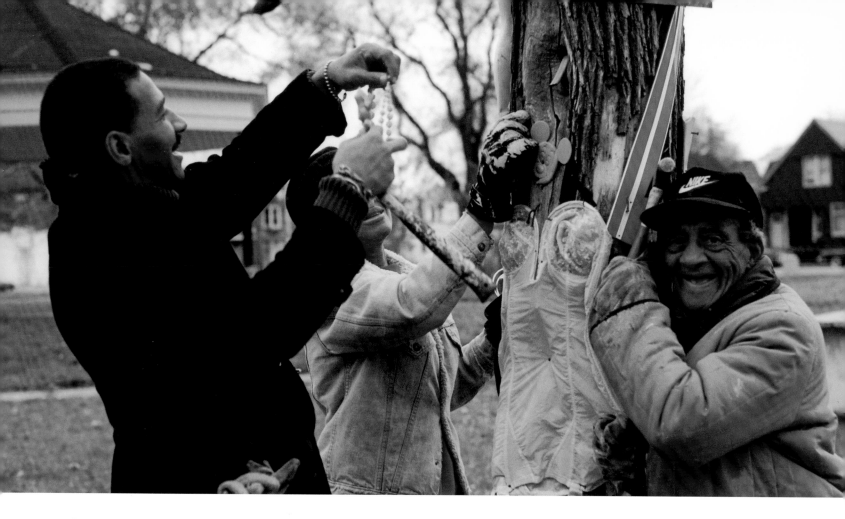

they were not as ready to face life's adversities as their fathers and grandfathers had been. They certainly had more schooling, but it takes more than lessons in school to make you wise, he said. His grandson, he added, was one of the wise ones. "God gave him five senses," Mackey said, "and he uses them like he's supposed to. I wanted to be president when I was nine years old, but I knew there wasn't a chance. Still, that's what I wanted to do. Tyree wants to paint."

In 1992, on the day that Sam died of cardiac arrest at ninety-four in a Detroit hospital, I spoke with Guyton about his life with his grandfather. "Everywhere he went," Guyton said, "he took me with him. He taught me how to paint, but there was so much more to it than that. It was a unique and incredible relationship. He was more than just a grandfather. He was my friend, and he was everything a person could ever ask for in a friend."

Sadly, I had seen less of Sam in the previous two years. My assignment at the *Free Press* had changed, and I found it necessary to spend more of my time in the office and much less of it hanging around places like the Heidelberg Project.

I saw him on a Sunday morning in November 1991, a couple of hours after the City of Detroit, in a remarkable display of political spite, bulldozed the Heidelberg Project. Guyton and Mackey were given fifteen minutes to remove whatever pieces of art they could manage before the wreckers moved in. Most of Sam's art was lost in the demolition.

Sam didn't say much that morning to anybody. When I got there, he was climbing slowly over the rubble, picking around broken boards, pushing broken window frames and pieces of masonry aside with his foot. From time to time he would stop and reach into the wreckage to retrieve something he recognized—a piece of board splashed with bright colors, a broken picture frame, a plywood square with a grinning face painted on it. He would brush the splinters and brick-dust off the pieces and carry them to a tree near the sidewalk and carefully place them against its trunk.

Like me, several people drove to Heidelberg after they heard about the destruction from the city's morning television news programs. When they got there, they stood around in small groups, speaking quietly among themselves with a kind of funeral home awkwardness, not quite sure what to say to Tyree Guyton or Sam Mackey. Whenever one of them approached Sam to offer words of consolation or softly touched the sleeve of his coat, he looked at the person sadly, listened, nodded his head, and then continued to pick his way through the debris.

I did not speak to Sam that morning. I knew there was nothing I could say that would help soften the pain of what had happened. So I said nothing. I stood in the street, watching him move through the pieces of what had been such a vital part of his life. He looked like a man who had just lost something important. At one point he looked in my direction and I thought he was going to say something. But he just shrugged, shook his head, and continued to walk through the ruins.

Our last extended conversation was in September 1989. I was doing a story about the city for *Detroit Magazine*. I called and told him I wanted to interview him for the article. He said he didn't like being interviewed. He said why didn't I just come by and we could talk.

We sat on the bench that afternoon and talked. He took an orange out of his pocket, peeled it, and handed half to me. I no longer remember how we got started talking about

mortality, but he told me that day that he knew a lot about living and dying.

"Across there," he said, pointing to the empty lots across the street with the wooden-handled paring knife he had used to peel the orange. "There was houses there. A Jewish fella lived there and next to him was an Italian fella and right there was an American fella.

"Two old maids lived over there, right side of the machine shop that was on the corner. Very nice people. But their family came and took them away when they got old.

"All these things were alive once," he said, pointing his knife at the profusion of discards piled on the roof of the abandoned house and nailed to its sides.

"People throw things away when they can't see the beauty in them anymore," he said. "But we have to still look at it the same as when it was part of some people's life. You don't need to be smart to understand that.

"You get old, and you're soon forgotten. People forget all you've done, everything you've been. They forget you've had any kind of experience, forget you were once a young boy. But if you're old, you can never be young again; you can't stay a baby all your life.

"Old will never be young again," he said that day, "and in time everything on Earth changes. The grass gets brown and dies, but then it grows back. Spreads its own seed and grows back again."

The Heidelberg Project marked twenty years of existence in 2006. In February the Arts Exchange Gallery and Museum at 2966 Woodward began showing the art of Sam Mackey and Tyree Guyton, an exhibition to honor both the anniversary of the project and the men who created it. I visited the exhibition in April.

The gallery is in an upstairs space above a restaurant. The morning I went there a man was mopping the hallway outside the restaurant. I apologized for walking on his freshly washed floor and asked him how to get to the gallery. He told me not to worry about the floor and pointed to the elevator with the handle of his mop.

The gallery had not opened yet, but the door was unlocked and I went inside. The only light in the big room came from the windows that overlook Woodward, but it was sufficient to see the painted people looking down at me from the walls. Sam's people—a mixed media of paint, crayon, and ballpoint creations, a roomful of those familiar round faces with rectan-

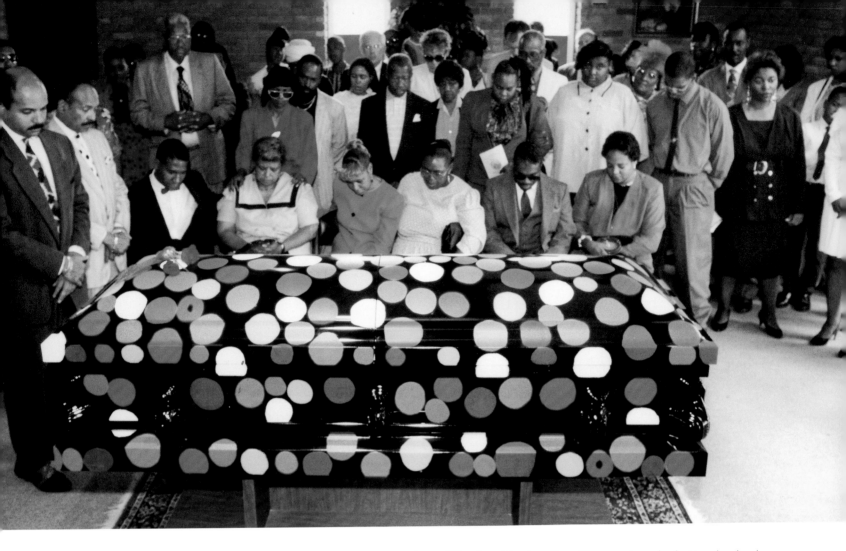

gular eyebrows, L-shaped noses, and wide grins filled with teeth. Some had dotted circles on their chests.

I stood in the half-light of the room, surrounded by his work—signed variously "Sam Mack," "Sam Mackey 3658 Heidelberg," "Grandpa Mack," or just "Granpa"—and listened for psychic echoes. The only sounds came from outside: the morning traffic on Woodward, some workers on Watson Street tearing up the sidewalk, three men laughing loudly outside the storefront offering twenty-four-hour check cashing. On the west side of Woodward the driver of a car double parked in front of the Motor City Cutz hair salon ("Braider on Duty") was tapping the horn every few seconds.

But I could feel Sam's presence. It filled the room, softening the outside noise.

That same morning, two miles east of the gallery, things were much quieter on Heidelberg Street. It's an old street, its name a relic of the German immigrants who settled there in the early years of the last century. During World War I the name of its Germanic

sister to the south, Berlin Street, was changed to Benson. For some unexplained reason that apparent burst of patriotic zeal did not include Heidelberg.

The drivers of the occasional car or pickup truck moving down Heidelberg that sunny morning didn't pause to glance at the polka-dotted house at 3658, the house with the picture of Martin Luther King near the door and the tombstone resting next to the front porch steps with the name "McKinney" cut into its surface. Nor did any of them stop or even slow down to look at the profusion of stuffed toys, old shoes, TV sets, signs, dolls, or the collective representations of God in various artistic incarnations; the life of the city, past and present, cherished and then discarded, nailed to trees, posts, and old houses or simply filling vacant lots

Mackey's polka-dot casket, 1992. HEIDELBERG ARCHIVES. never meant to be vacant. The drivers were locals, most probably, cutting across Heidelberg to get to Mt. Elliott Street on their way to somewhere else. If there was beauty there, it was for the eyes of others with less to do that morning.

On Heidelberg that day the midmorning sun was warming the air, and winter was grudgingly giving way to the promise of a softer time to come. Spring was beginning to show its green in the trees and shrubs. It was a day that Sam Mackey would have loved.

There's a green park bench across Heidelberg from Sam's house. Beneath it, bits of grass have forced their way through the hard yellow dirt, showing green against the clay. On the seat was a plywood board, a long rectangle, its laminate peeling. Eight round heads were painted on the board, bright figures with wide round eyes and lots of teeth. It was resting upside down on the bench.

I didn't look to see if anything on the back of the bench identified it as the property of the Detroit Department of Parks and Boulevards.

I have long since decided that, in some past incarnation, the place might indeed have been a park. ●

Neal Shine is the retired publisher and president of the *Detroit Free Press* and professor emeritus of journalism at Oakland University in Rochester, Michigan.

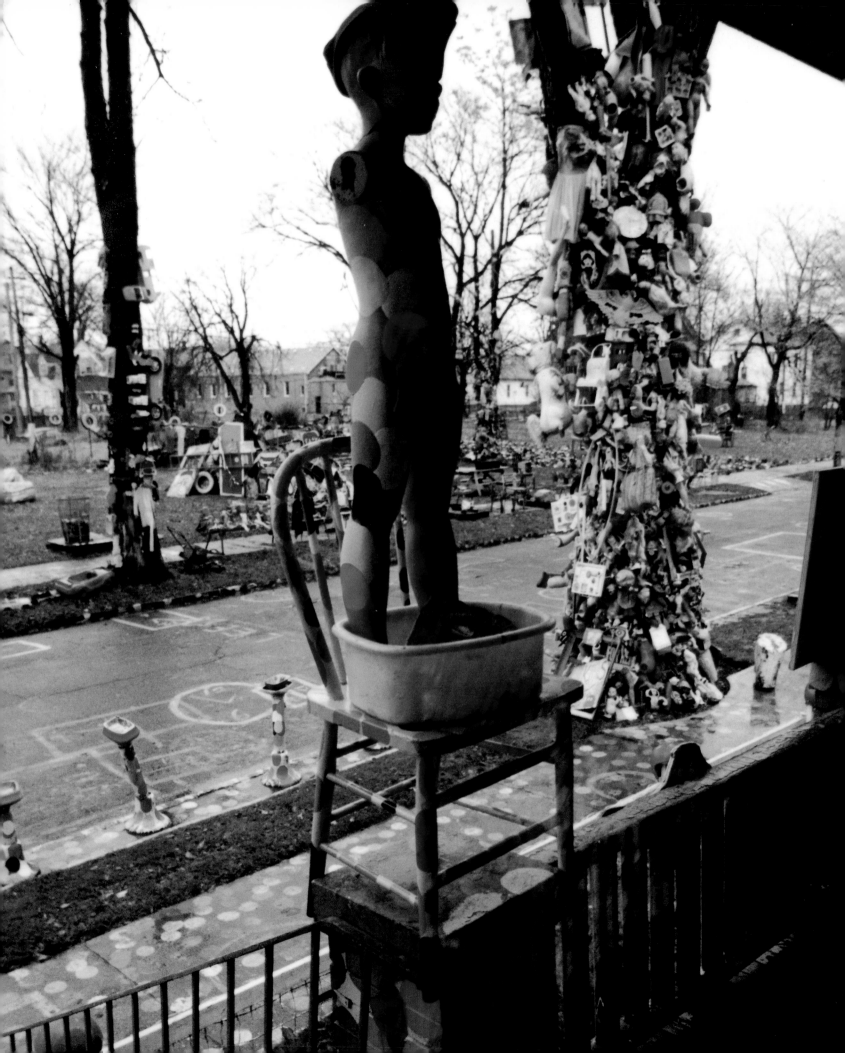

MARION E. JACKSON

TRICKSTER IN THE CITY

Polka-dot mannequin on porch of Dotty Wotty House, 1992. HEIDELBERG ARCHIVES.

Oh you, bear witness that I have done my duty

Like a master alchemist and blessed soul

For from these things, I extracted the quintessence.

You dealt me filth and I turned it into gold.

Charles Baudelaire

Large painted dots...stuffed animals squeezed into boarded window frames...shoes swinging freely from golden branches of autumn trees...a parade of swaggering vacuum cleaners...boldly painted faces smiling from bent car hoods...star-spangled banners wrapped around trees and painted on weathered boards...bedsprings... posters...street signs...long-lost dolls with missing limbs and dented faces...shoes...bathtubs...wooden crosses...hubcaps...and dots...colored dots...more dots...an entire house painted with polka dots...a photograph of Martin Luther King Jr....and dots, more polka dots.

The cacophonous outpouring of colors, shapes, and forms and surprising juxtapositions of discarded objects have animated the first block of Heidelberg Street, just west of Mt. Elliott Street, on Detroit's East Side since 1986. In continuous flux throughout its twenty-year history, the Heidelberg Project is a creative environment envisioned and shaped by Detroit artist Tyree Guyton, who grew to adulthood in this neighborhood and who turned the neighborhood itself into the site and subject of his art. It is a creative oasis in an old neighborhood that—like many of Detroit's old neighborhoods—is rife with abandoned houses and vacant lots and has a troubled history of poverty, social degradation, and crime.

Recalling the beginning of the Heidelberg Project, Guyton describes stepping onto his front porch one morning in 1986 and hearing—in the hushed tones of his neighborhood—the soft crying of a wounded city. Less than twenty years earlier, when Guyton was an impressionable twelve-year-old boy, Detroit had suffered one of America's most violent and destructive race riots; Guyton's own neighborhood had been a site of extended and uncontained looting and arson. By 1986, festering racism in the aftermath of the 1967 riots, white flight from the city, economic decline, and urban malaise had reduced Detroit from the city of nearly two million lauded as the "Arsenal of Democracy" at midcentury to a city of approximately

one million with a new and unenviable reputation as the murder capital of the United States. That morning in 1986 Guyton heard the discordant tones of poverty and discouragement all about him. He knew in his heart that he wanted to respond, that he wanted to transform his neighborhood and revitalize the spirits of the people desensitized by anger and numbed by despair.

Tyree Guyton, then thirty-one, had experienced the deterioration of the city alongside his demoralized neighbors; like his neighbors, he had little in the way of material resources. He did, however, have a vision and an uncanny sense of hope; he aspired to become a full-time artist, and he drew strength from his heritage and the lessons of his mentors. Guyton thought of his mother, Betty Solomon Guyton, a seamstress and domestic worker, and remembered how she had struggled during his childhood to meet her family's needs through improvisation and invention, mending and altering hand-me-down clothing to dress her children and making patchwork quilts to keep them warm. He remembered too how his grandfather Sam Mackey, a housepainter, had placed a paintbrush in his grandson's hand when he was only nine, giving him a sudden awareness of the power of paint to transform a drab world into a new and brighter reality. Guyton remembered as well the wisdom of Detroit artist Charles McGee, who counseled him to forget the academic conventions of his formal art training (at the Franklin Adult Education program, the Center for Creative Studies [later, the College of Creative Studies], Wayne County Community College, and Marygrove College), get in touch with his own spirit, and express that spirit by whatever means he could.

Thus in 1986 Tyree Guyton set out to transform his neighborhood through art. He began to paint furiously, creating colorful forms and figures on abandoned houses in his block of Heidelberg Street and in adjoining blocks. With help from his then-wife, Karen, and his grandfather, Guyton walked through alleys and drove an old pickup truck through neglected streets of Detroit, collecting discarded objects to create sculptural constructions on vacant lots along Heidelberg Street. Before long, fascinating assemblages of painted doors, stacks of tires, constructions of car hoods, and rows of drinking fountains and vacuum cleaners began to appear in the empty lots. Guyton nailed truck tires, baby dolls, telephones, and other objects to the exteriors of abandoned houses and hung bicycles, shoes, and other objects

from the trees. Painted dots, circles, lines, abstract shapes, and occasional numbers or words in bright colors punctuated the scene.

Tyree, Karen, and Grandpa Mackey cleared the brush from vacant lots, swept sidewalks, planted flowers, created magical paths of crushed rock, and improvised playgrounds, complete with rope swings and tunnels of tires through which neighborhood children could jump or crawl. This hopeful threesome worked hard at transforming the neighborhood, and people began to respond. Children began to use the new playground and to add their laughter to the reclaimed space; neighbors felt safer walking in the neighborhood; drugs and drug dealers became less of a presence. Some neighbors began to pay more attention to the appearance of their own properties, painting, cleaning, and planting gardens. Guyton erected a painted sign at the corner of Heidelberg and Mt. Elliott streets that identified the Heidelberg Project and welcomed visitors.

News of the Heidelberg Project spread, and "outsiders" began to stop by. Visitors—numerous and diverse—came not just from Detroit and its suburbs but from other cities, other states, and other countries as public awareness of this unique urban art environment spread. Guyton and the Heidelberg Project received coverage in the Detroit media, and he got mentions in *Newsweek* magazine and on Tom Brokaw's *NBC Nightly News*. In 1989, just three years after initiating the Heidelberg Project, Tyree Guyton received the Spirit of Detroit Award from the Detroit City Council. The following year he was invited to present a one-person exhibition as part of the Detroit Institute of Arts' Ongoing Michigan Artists Program, which showcased prominent state artists. In 1992 Guyton received the Michigan Artist of the Year Award from Governor John Engler and the Humanity in the Arts Award from Wayne State University.

Not all responses to the Heidelberg Project were so positive. Some neighbors complained about the visitors who were walking through their neighborhood and objected to the flow of cars and tour buses along their narrow streets. They resented the very idea of being part of the spectacle created by the Heidelberg Project. Others simply did not like the Heidelberg Project. They argued that the discarded objects from which the project was constructed were nothing but trash, and did not see the brightly painted constructions as art. They did not want the trash in their backyards. Twice—in 1991 and again in 1999—the City

of Detroit responded to citizen complaints and moved in with bulldozers to demolish significant portions of the project that stood on abandoned lots that had defaulted to the city for nonpayment of taxes. However, the demolition crews did not touch houses and sculptures on privately owned lots, including the lot owned by Tyree's mother, and today these areas continue to form the core of the still-evolving Heidelberg Project.

Responding with equanimity to diverse reactions, positive and negative, Guyton has persisted in his creative efforts and in his belief that the art of the Heidelberg Project can heal the wounds of the city and bring about redemption for individuals and society. As the Heidelberg Project celebrates its twentieth anniversary, it continues to attract a steady stream of visitors. It ranks among the top cultural destinations in Detroit, and volunteers and supporters of the project continue to grow in numbers. Popular and critical interest in the Heidelberg Project continues, as evidenced by the extensive international media coverage and by Guyton's popularity as an invited speaker and exhibiting artist at numerous university and civic sites in the United States, Europe, and South America. Likewise, the project remains a site of controversy and has its detractors, some still arguing that the Heidelberg Project is literally a heap of trash that should be hauled away. Less hostile dissenters argue, often with incredulity, that if the Heidelberg Project is really art, it should be relocated to a more appropriate cultural site, such as a museum, where it would be less of a disturbance to daily life.

Much of the controversy surrounding the Heidelberg Project seems to relate to the contested boundary between art and life and to notions about distinctions between the two. In this sense the Heidelberg Project is heir to the twentieth-century modernist debate by avant-garde artists in Europe and North America who have explored and challenged the boundaries between art and life.

In a catalog essay I wrote for Guyton's exhibition at the Detroit Institute of Arts in 1990 ("Tyree Guyton—Listenin' to His Art"), I placed his work in the artistic lineage of Marcel Duchamp and Robert Rauschenberg and suggested that the Heidelberg Project operates in what Rauschenberg termed the gap between art and life. "The Heidelberg Project," I argued, "is not *about* something; it *is* something" (7).

A few years later, Jerry Herron, professor of English and an American culture scholar

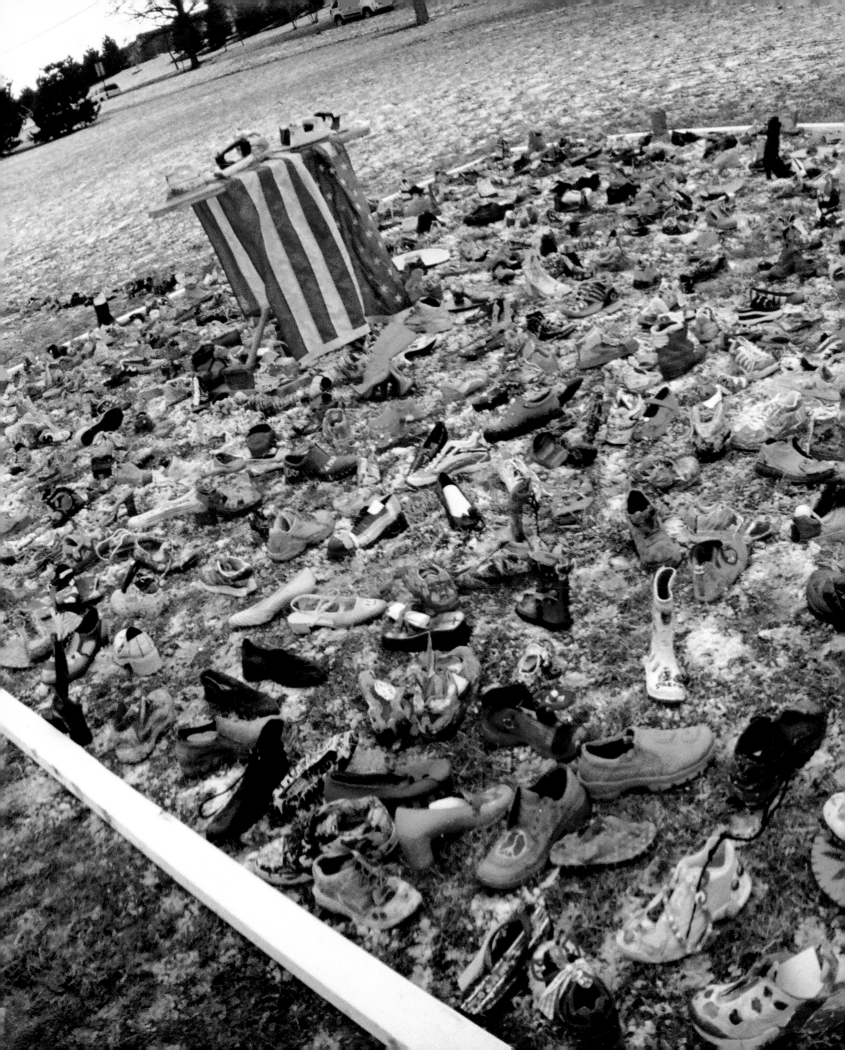

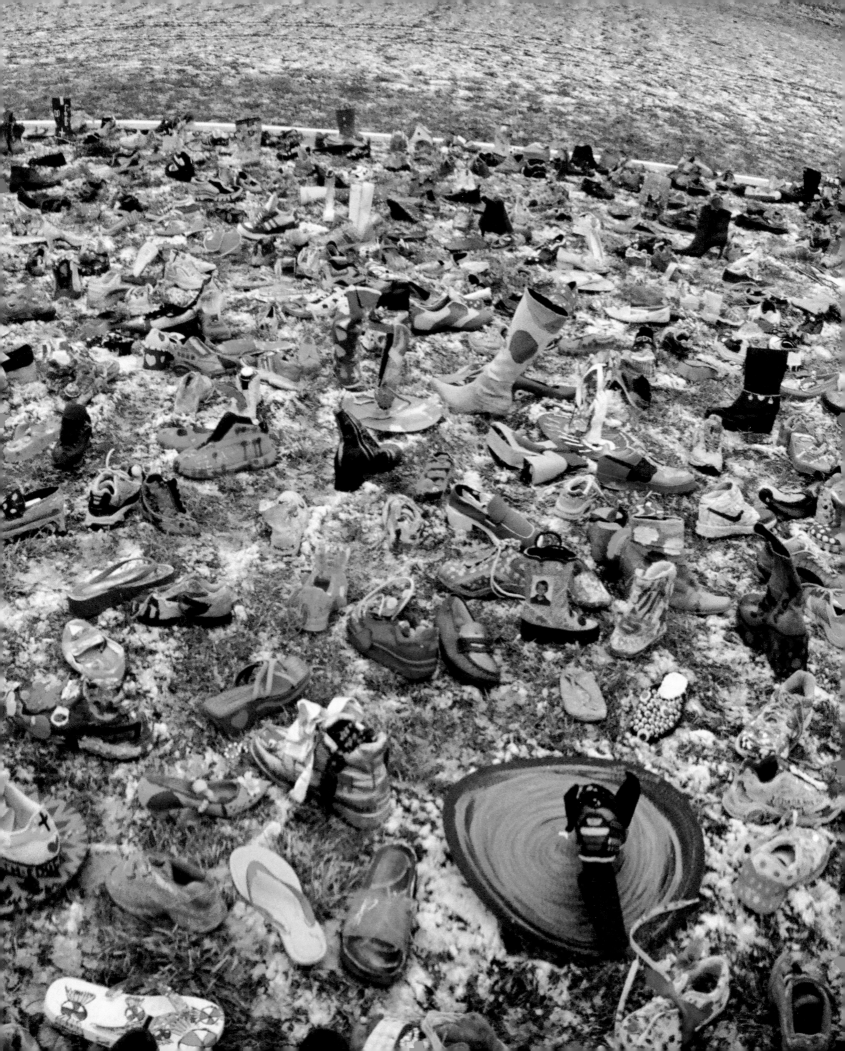

at Wayne State University, took quite a different view of the Heidelberg Project in his book *AfterCulture: Detroit and the Humiliation of History* (Wayne State University Press, 1993). Herron argued that the Heidelberg Project is a referential work of art that critiques the harsh reality of the demise of the city, the decay of dreams and hopes, and Detroit's shame in its own history. Herron's word choices reveal his disconsolate view:

> [Guyton's] houses literally vomit forth the physical elements of domestic history; furniture, dolls, television sets, signs, toilets, enema bottles, beds, tires, baby buggies come cascading out doors and windows and through holes in the roof, flowing down the outside walls and collecting in great heaps on the lawn, so that the whole looks like some sort of man-made lava flow. The magma of discarded lives; these visible tokens of a humiliated history. (199)

At the time I thought that his rather dark interpretation, though interesting, was simply *too* gloomy and had to be wrong. Now, a dozen years later, on the *Oval Office*, 2003. HAROLD GROSS. ▶ twentieth anniversary of the Heidelberg Project, I have come to the paradoxical conclusion that Herron and I were *both* right—and wrong. Each of us saw the project from the perspective of our own experience. As Herron suspected, I was responding to the aesthetic stimulation and was excited by the energy and improvisation in the colorful constructions that Guyton had created from discarded objects. I saw in their reclamation the surging of hope for a new life. Herron, in contrast, was studying and writing about the demise of the metropolis and saw Guyton's assemblages of broken dolls and discarded debris as emblematic of urban decay and the humiliation of the urban dream. Today I think that we were both wrong in our presumption that the Heidelberg Project actually effuses anything like a unified meaning discernible from a single point of view.

The actual nature of the Heidelberg Project is a fluid and contested arena of knowledge; one can wonder whether divergent interpretations are simply a function of the differing perspectives of different viewers or whether qualities of the Heidelberg Project itself support or engender strikingly divergent responses. For that matter, one can wonder why the

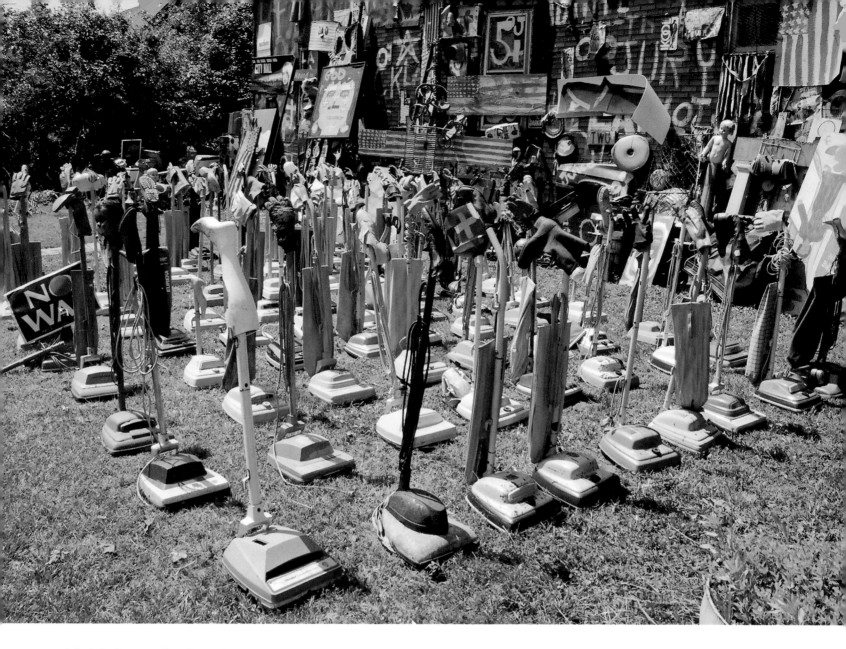

Heidelberg Project has catalyzed so much controversy, especially around the question of art versus trash.

This latter question has at times become quite heated and was even the subject of a court case in 1999. After the city preemptively demolished several Heidelberg structures in 1999 as well as an off-site residence on Canfield Street containing several dozen works of his art, Guyton sued, seeking an injunction against further demolition and compensation for the value of the destroyed artwork. In the resulting jury trial the city's lawyers argued unsuccessfully that the Heidelberg Project and other destroyed objects were not art and therefore not of value. Although the verdict held that Guyton's work is a genuine artistic expression protected under the First Amendment to the U.S. Constitution, and the court issued an injunc-

tion against further demolition of works on private property, Guyton was awarded no compensation for destroyed artworks. That this question could be debated in a court of law, with contradictory testimony from expert witnesses, is emblematic of the level of disagreement that has swirled around the Heidelberg Project.

I Hear You Knockin'—Won't You Please Come In

Why such different interpretations and why so much controversy? And is it art or trash? Since the mid–nineteenth century, art identified as avant-garde or "cutting edge" has been a rebellious expression by artists who have departed in radical ways from the traditional conventions of art history. The last 150 years of artistic production are marked by a rapid succession of innovative and initially controversial approaches, each new approach surpassing

THE BOUNDARIES BETWEEN
AND THE VIEWER HAD BECOM

its immediate predecessor with confrontational new ideas about style or subject matter or both. While these artistic advances have not followed a straight or single path, most have been in the general direction of shocking the viewer out of perceptual complacency, challenging existing definitions of art, and expanding normative modes of art practice.

Avant-garde artists of the nineteenth century began to experiment with new ways to capture their impressions of fleeting moments in nature and with new abstract forms to depict the invisible structure of the universe. At the turn of the twentieth century, Pablo Picasso and Georges Braque developed startlingly new ways of fragmenting and juxtaposing splintered forms to represent multiple perspectives in a single composition in their experiments with cubism. And the wily surrealist artist Duchamp scandalized the art world in 1917 with the brazen idea that art could take any form when he signed and dated a commonplace, commercially manufactured urinal and placed it in a gallery as a work of art. Duchamp's appropriation of "found objects" challenged the comfortable distinction between life and art and outraged an audience resistant to his irreverent flouting of cultural convention.

Innovations in both practice and theory continued throughout the twentieth century, and successive generations of artists in Europe and the Americas extended the boundaries of art to include even more diverse styles, even more impudent strategies, and an increasingly wide range of materials and methods. Rauschenberg, in the 1950s, audaciously overstepped the boundaries between art and life in works presaging the pop art movement of the 1960s by integrating commonplace objects (Coca-Cola bottles, tires, newspapers, photographs, and the like) into his three-dimensional, painted assemblages—aptly termed *combines*—that seemed to tumble ungracefully from gallery walls. In the 1960s avant-garde artists rebelled against the privileged authority of the gallery itself and moved their art to billboards, street murals, subway trains, and other temporary public venues. Even the authority of the artist and the conventional distance between the viewer and the work of art were put into question

THE ARTWORK, THE ARTIST, CONTESTED AND TENUOUS.'

by performance artists in the 1970s. In his enigmatic performance art, Joseph Beuys refused to allow viewers to remain passive receivers and, instead, often involved them as interactive participants and collaborators. Thus by the end of the twentieth century the traditional object-based notion of art had been reconceptualized, and the boundaries between the artwork, the artist, and the viewer had become contested and tenuous.

Today, growing numbers of contemporary artists around the world extend even further the interactive aspects of art, completely replacing the object-based notion of art with a concept of art as an interactive social process. According to this view, art becomes both the locus and the impetus for dialogue and exchange. In his insightful book *Conversation Pieces: Community and Communication in Modern Art* (University of California Press, 2004), art critic Grant Kester identifies these new socially based approaches to art as "dialogic art" in which a work of art is conceived not as a self-contained expressive object but as an *event*—"intended to produce a transformation in the viewer's consciousness of the world" (62).

Among the many dialogic artists cited by Kester is California artist Suzanne Lacey,

whose performance-based projects since the mid-1970s have created opportunities for public exchanges among diverse groups that might otherwise lack personal contact with one another. Lacey's *Code 33: Emergency, Clear the Air* project of 1999 involved improvised public conversations between police officers (primarily European American) and young people (primarily Hispanic) seated together at tables on the rooftop of a parking garage in Oakland, California. Their face-to-face discussion of controversial social issues such as media stereotypes and racial profiling was illuminated by the headlights of one hundred police cars and recorded for broadcast.

Dialogic art, as Kester describes it, is transformative in the way that art has always been transformative, awakening insights and freeing viewers from the complacency of conventional thinking. However, dialogic art functions according to a new paradigm, one that redefines the aesthetic experience as durational rather than immediate. A work of art is not a fixed object but rather a fluid locus for creative dialogue and exchange; this creative dialogue is collaborative, actively involving both artist and audience and enabling both to transcend convention and to see the world anew.

The Heidelberg Project fits the model of dialogic art that Kester describes. From the outset Tyree Guyton has welcomed the presence of visitors who mingle, converse, and sometimes even argue among the installations of the Heidelberg Project. He is frequently present on the site and enters easily into conversation with visitors. From the beginning he has encouraged neighborhood children to join his creative effort and has given them paintbrushes and bright colors, encouraging them to make their marks in the evolving art environment. Similarly, art students from nearby colleges and universities have been welcomed and have been encouraged to add their own distinctive marks to the project. Guyton gladly welcomes visitors' contributions of objects of any sort, and he embraces the inevitable trans-

Guyton's tribute to homelessness in Detroit, 1988. HEIDELBERG ARCHIVES. formations resulting from weather and wear as part of the project's creative dynamic. His artistic vision is notably fluid and nonprescriptive. While he addresses issues of poverty, racism, violence, and injustice in America through his selection and juxtaposition of objects, and while he alludes, through graffiti-like text, to specific events and divisive social issues such as the O. J. Simpson trial or the Detroit race riots of 1967, he does not offer judgment. Rather, he sees his art "as a medicine of hope." "It makes people think," he says on his website, "…it asks questions" (www.heidelberg.org).

While Guyton intends the Heidelberg Project to be welcoming to all people, he also embraces differences among people and does not presume that all visitors will have the same reactions. Multicolored polka dots bouncing over the structures of the Heidelberg Project acknowledge not just the many colors of the spectrum but also the many and diverse people of the world. Likewise, the dozens of car hoods with boldly painted faces positioned throughout the project form part of an open-ended series titled *The Many Faces of God* and affirm the lively diversity within the human community. When visitors are present—wandering through the art-laden lots or driving down Heidelberg Street—they too become part of the art environment. For visitors the colorful assemblages of familiar objects lifted from their context in daily life take on new and unexpected meanings and can spark associations and new ideas. Conversations are inevitable, and the role of the visitor can shift quickly from passive viewer to active participant or collaborator. The multisensual visual, aural, and tactile stimulation of the Heidelberg Project creates a liminal space in which daily life and the normal roles and obligations of the

visitor are momentarily forgotten, freeing individuals to interact in new and unforeseen ways. The Heidelberg Project itself blurs boundaries—between past and present, between object and idea, between memory and desire, between art and life—and facilitates dialogue across all these boundaries without sacrificing the identity of individual speakers.

But to understand the dynamic energy of the project, one must look to the project itself and, through the project, to the origins and functions of art. Recognizing the transformative and disruptive potential of art, cultural critic Lewis Hyde likens the artist in modern society to the trickster in mythology—to the wily messenger spirit Eshu of the Yoruba and the Fon of West Africa, to Hermes of ancient Greece, to Krishna of India, and to Coyote of the indigenous people of North America. In his book *Trickster Makes This World: Mischief, Myth, and Art* (North Point Press, 1998), Hyde notes that these trickster figures are "boundary crossers," ceaselessly transgressing the seemingly impenetrable borders between the known and the unknown, between the mundane and the spiritual, and between human beings and the gods.

The propensity to challenge boundaries, disrupt convention, and disorient unsuspecting observers characterizes, in Hyde's view, not just the activity of the trickster but the activity of the artist as well. Tracing the etymology of the English word *art* to its origins in the Latin words *ars* (meaning "skill," "artifice," or "craft") and *artus* (meaning "joint" or "point of articulation"), Hyde suggests that the original concept of artist was not just as a maker of objects (as befits our conventional thinking) but also as a "joint worker" who stimulates change at the turning points of culture, disrupting tired conventions and interjecting imaginative new possibilities. Like the trickster, the artist disregards "normal rules," throws viewers off balance and—often through guile—forces viewers to perceive or imagine the world in new ways. The artist, as Hyde points out, is the *artus*-worker, or "joint worker," who disrupts the banality of stereotypical expectation and catalyzes vision and action at points of potential cultural change.

Eshu, the trickster in the Yoruba tradition, arrived in the Americas on slave ships from Africa in the sixteenth century and has cunningly insinuated himself into American culture. In Brazil, Haiti, Cuba, and areas of North America where traditional African religious practices persist or have undergone revival, Eshu is recognized as a wily and mischievous messenger with powers of prophecy and divination and the ability to provoke communication. In every-

day life, Eshu is the animating spirit of the crossroads, the embodiment of creativity and imagination. Eshu operates in the midst of controversy and confusion; he is at the eye of the storm, in the middle of the whirlwind. In a popular West African folktale, Eshu places on his head a hat which is sewn from two pieces of cloth—black cloth on one side and white cloth on the other. Wearing this two-sided cap, Eshu mounts a horse and rides between two friends working in a field. Shortly after, the two friends pause in their work and comment to one another on the stranger who recently passed by—one friend noting the stranger's attractive white cap and the other insisting the cap was black. As the story continues, the two friends fall into heated argument over the color of the cap and begin to fight; soon onlookers become involved and try to restrain the combatants. At this point, Eshu returns, laughing and wearing the two-sided cap that injected the ragged energy of controversy into a seemingly peaceful day.

The parallels that Hyde sees in the work of the trickster and the work of the artist may help to explain the energy and the controversy that have swirled around the Heidelberg Project throughout its twenty-year history. Neither a neatly contained aesthetic construction reinforcing conventional ideas of art nor, strictly speaking, a deteriorated neighborhood in a deteriorating city, the Heidelberg Project breaks the rules and resists classification. By its very contrariness the project attracts interest, provokes discussion, and challenges boundaries of conventional thinking. Artist Tyree Guyton becomes an *artus*-worker, a joint-disturber, an artist in the tradition of the mythological trickster who unsettles our certainties and reminds us of the slippery nature of that which we unquestioningly accept as truth. Enabling us to glimpse momentarily beyond prescribed perspectives, the Heidelberg Project floods us with multisensory stimulation, puts us face-to-face with others, often including the artist, and reminds us that there are realities beyond our daily experience. ●

Marion E. Jackson is a professor of art history at Wayne State University and served as a member of the Heidelberg Project Board of Directors from its inception in 1988 until 2000. She has curated exhibitions and lectured and written widely on popular art of the Americas, with emphasis on African American, African Brazilian, and Canadian Inuit art traditions.

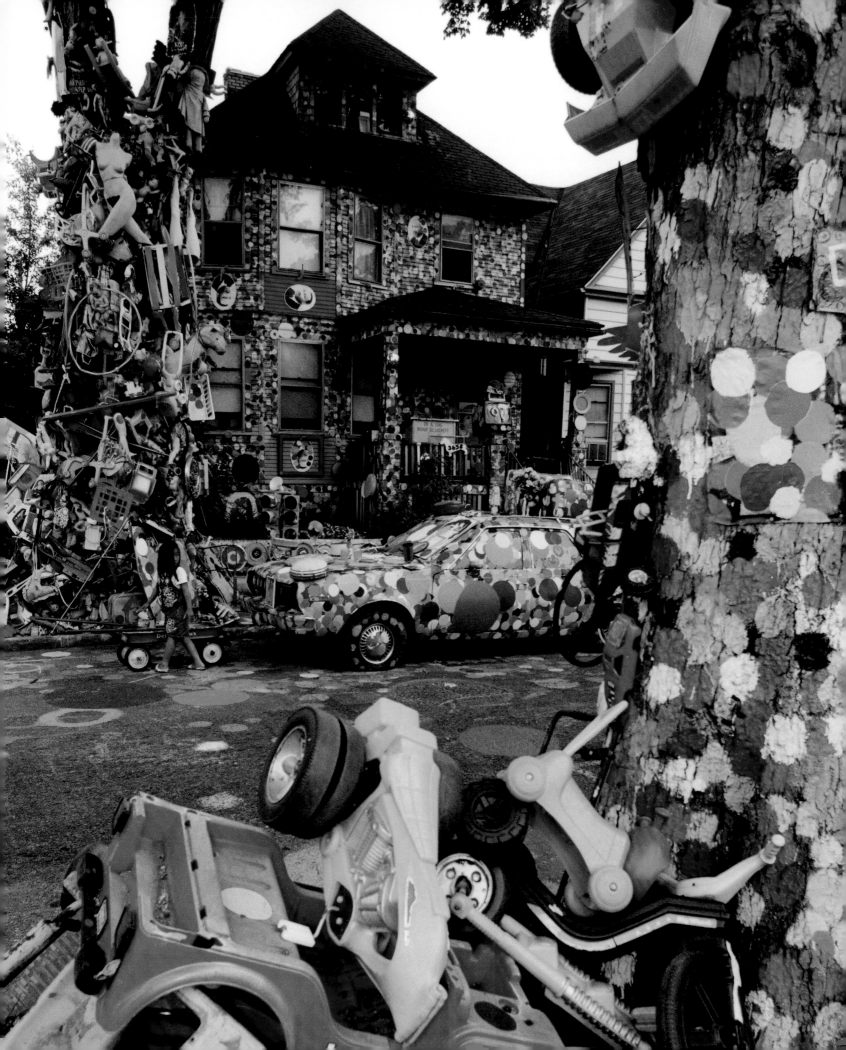

ART OR EYESORE?

JOHN BEARDSLEY

Dotty Wotty House and the Dotty Wotty Car, 1995. DONNA TEREK.

On February 4 and 5, 1999, the City of Detroit invaded its own East Side with cherry pickers, front-end loaders, dump trucks, and helicopters escorted by police.

The target was neither a dangerous criminal nor an enemy, foreign or domestic. It was the work of an artist.

While police cars blocked the streets, public service employees tore down hundreds of objects that sculptor Tyree Guyton had hung in trees, and they demolished two vacant houses that he had turned into giant works of assemblage art—one on Heidelberg Street, another on Canfield. The former, which Guyton had titled Happy Feet, was festooned with shoes; the latter was similarly decorated on the outside and contained countless paintings and sculptures by the artist on the inside, all of which were destroyed. The city claimed the abandoned dwellings were safety hazards.

This wasn't the first time that Detroit's leaders had made Guyton their target. In the early hours of November 23, 1991, bulldozers had also rumbled onto Heidelberg Street, destroying four derelict houses that Guyton had transformed with his art. The origins of the conflict between the artist and the city go back to 1986 when, with the help of his grandfather Sam Mackey and his then-wife, Karen, Guyton had all but obliterated the houses under layers of scavenged materials—tires, hubcaps, broken toys, battered dolls, rusty signs, busted appliances, and automobile parts—all brightened with stripes, polka dots, and random splashes of paint.

His actions were an expression of both outrage and art. Then in his early thirties, Guyton had grown up on this street and had watched it decay, as family after family fled in the face of poverty and crime. Abandoned dwellings *Tithes and Offering,* 1995. DONNA TEREK. ▶ became crack houses. "You'll think I'm crazy," Guyton said, "but the houses began speaking to me. . . . Things were going down. You know, we're taught in school to look at problems and think of solutions. This was my solution." (Unless otherwise attributed, quotations are from conversations I had with Guyton.)

Disinvestment had made Guyton an urban guerrilla, a one-man adaptive reuse program. Perhaps more than he could have imagined, Guyton's actions put him at the center of a clash of values that illuminates the cultural and political complexities of contemporary urban life—in Detroit and elsewhere.

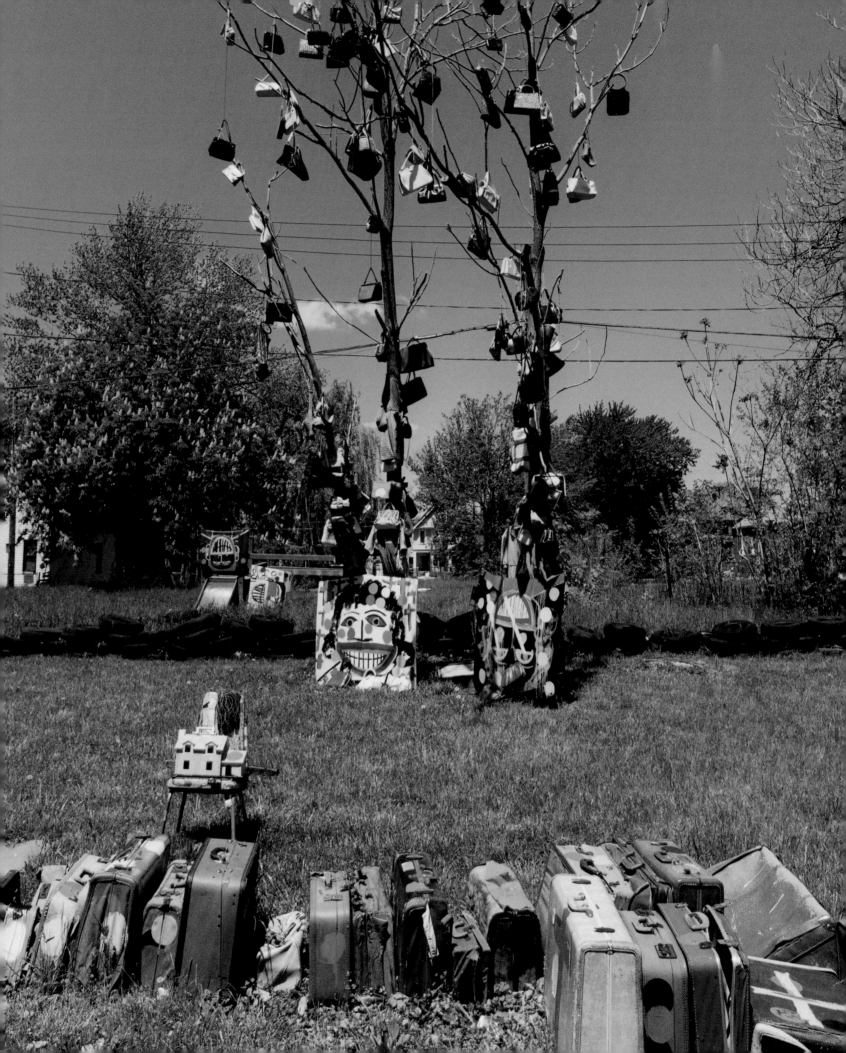

It is hardly surprising that the Heidelberg Project has been a lightning rod for inner-city frustrations. The kind of spontaneous, unsanctioned art created by the likes of Tyree Guyton typically has several audiences, often with distinctly different views. The pattern is the same for other monuments of what has been called outsider art (a term I use reluctantly), including the fabulous shell- and tile-encrusted Watts Towers in Los Angeles, which is the work of the late Italian immigrant Sam (or Simon) Rodia, and the Orange Show in Houston, a tribute to the health-giving properties of the orange built by Jeff McKissack, a retired mail carrier.

Opinion about these creations fractures somewhat along class and educational lines, although not entirely. Spontaneous constructions attract an international audience of well-educated art enthusiasts, and I include myself among them. Those who cleave to a notion of art as a critical or transformational practice typically applaud the way outsider artists thumb their noses at both artistic and social norms; connoisseurs appreciate the connections in

YOU KNOW, WE'RE TAUGHT I
AND THINK OF SOLUTIONS. THIS

work like Guyton's to a junk aesthetic that can be traced back through assemblage art at least to Kurt Schwitters's *Merzbau,* a profusion of grottolike chambers made by the German artist from salvaged materials in his Hanover house in the decades between the world wars.

Immediate neighbors, who are likely to be unfamiliar with such histories and who have to live with these offbeat constructions, are more likely to be intolerant of them. From a safer distance they are typically viewed with some curiosity. City bureaucrats, who often regard such installations as an affront to their authority, are usually the most hostile. In fairness, many unsanctioned creations are of dubious legality: Like parts of Guyton's project, they can constitute an instance of artistic "squatting," or occupation of condemned property. In such cases city officials tend to trot out city codes and regulations, sometimes in concert with neighborhood opposition, as a justification for the city's intervention.

Such was the case with an ambitious but ill-fated wooden ark that rose on city-owned vacant land in the ruins of Newark, New Jersey's Central Ward in the 1980s. The creation of

a woman named Kea Tawana, who worked in the construction trades, the ship was fabricated of scavenged materials; nearly ninety feet long and thirty feet high, it featured a hand-hewn keel and ribs joined by mortise and tenon. Like Guyton's houses, Tawana's ark was an emblem of resilience and survival in desperate circumstances. But city officials wanted it gone. Though she offered her creation to the city as a community facility and as a museum of shipbuilding techniques, they made her move and dismantle the ark, citing it with many safety and zoning violations. Apparently, Newark has no zoning that allows arks.

It is hard not to view this pattern of bureaucratic hostility to underground artists with some skepticism. I wonder whether city officials aren't motivated more by embarrassment than by sincere concern for their injured constituents. The attention generated by a Guyton or a Tawana underscores a municipality's inability to substantively improve poor neighborhoods. These failures are hardly personal—they are more the result of market forces and

SCHOOL TO LOOK AT PROBLEMS WAS MY SOLUTION.

demographic trends than bureaucratic indifference. Still, officials seem to have little tolerance for idiosyncrasy, notwithstanding that the harm done by the Heidelberg Project or Tawana's ark is minor compared with the social inequities caused by disinvestment in the inner cities. As icons of imaginative life, these places strike me as worthy of official sufferance, if not support. Like them or not, they are emblems of resurrection, of the capacity of individuals— arguably, even of communities—to re-create themselves from ruins, with or without official involvement.

My own efforts at evaluating Guyton's work express the larger divergence of opinion. On the one hand, as an aging product of the '60s counterculture, I am cynical of the city's motivation. Why target the Heidelberg Project when Detroit has plenty of other desperate neighborhoods and plenty of other derelict houses in need of demolition? As the *Free Press* columnist Heather Newman pointed out in 1998, "If Heidelberg were the last block of abandoned buildings in the city, I could see the logic in talking about dismantling the project to

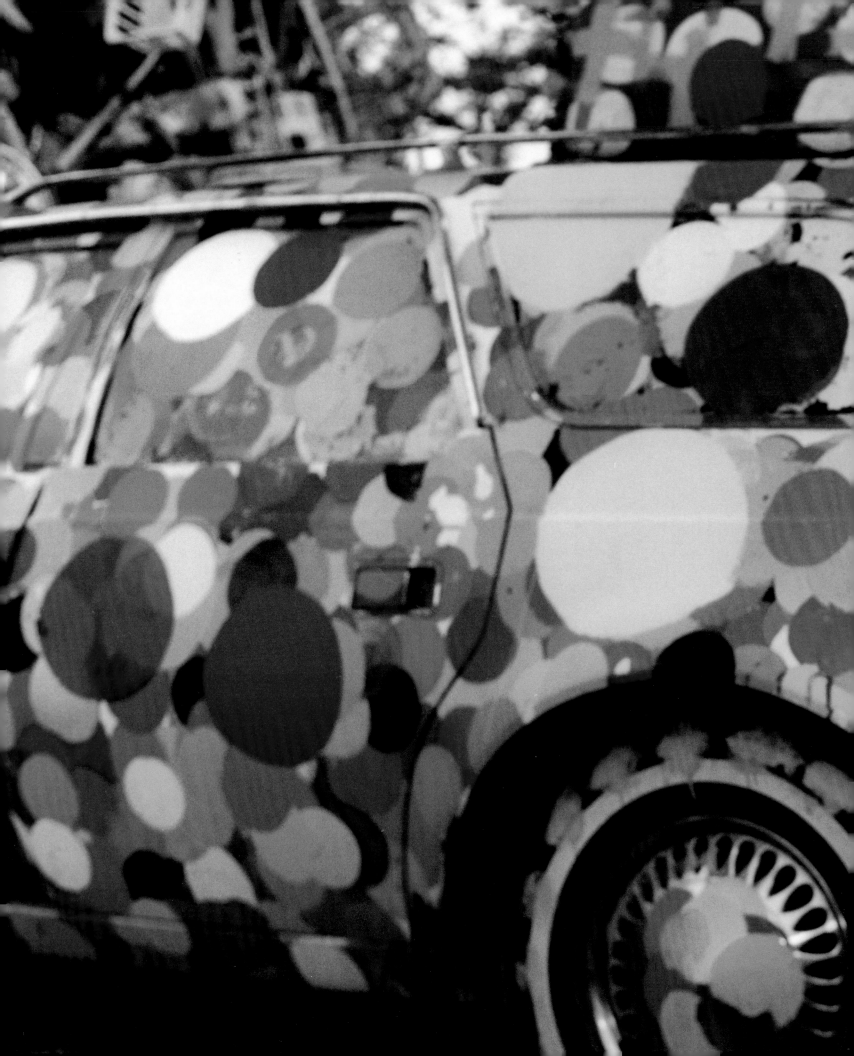

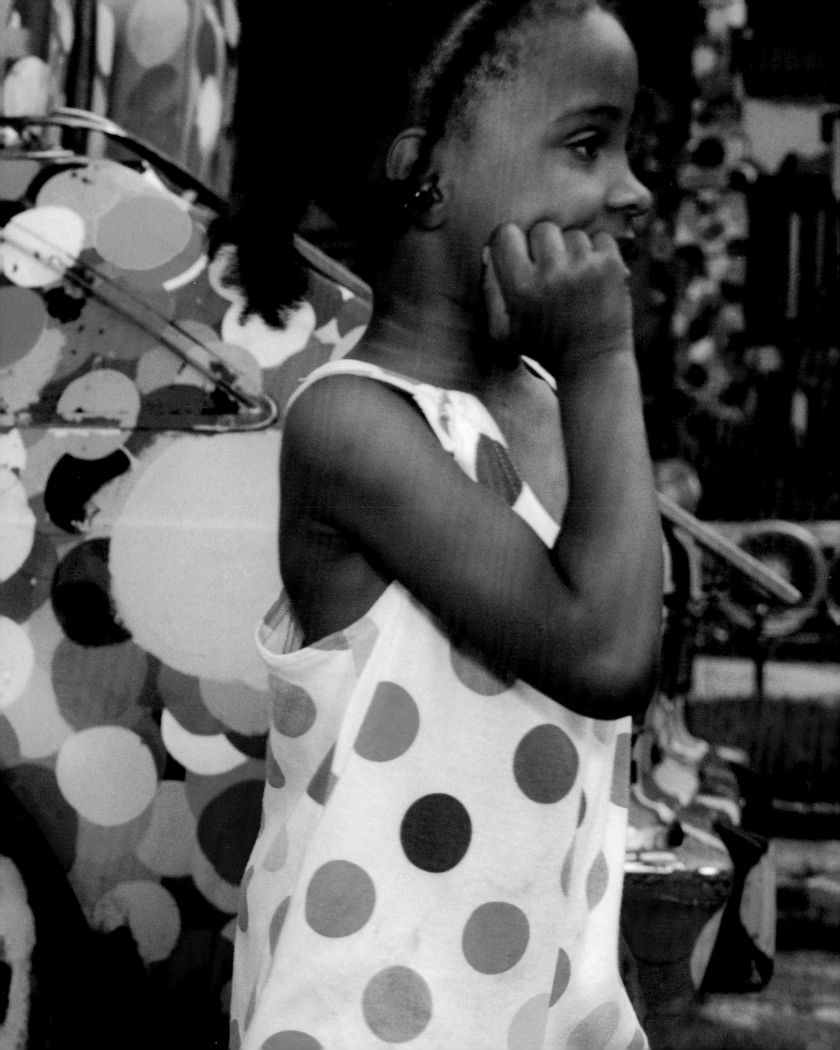

protect property values. But as we all know, it's not. And sadly, it's going to be a long time before it is, which is one of the points of Guyton's art in the first place." Going after artists like Guyton is a diversionary tactic, a crusade for officials with an urgent need for high-visibility accomplishments.

On the other hand, the inchoate communitarian in me feels some real sympathy for Guyton's neighbors. In a putative democracy some attention should be paid to community standards. This is not a simple matter of the artist's standing alone against a monolithic community—both sides have energetic and persuasive partisans. Perhaps what is called for is some sort of demographic analysis to determine the majority view—though questions of how the community would be defined and who House encrusted with relics from the city, 2002. ELAYNE GROSS. would be given a voice in this analysis raise potentially complex problems.

As an avowed partisan of the more offbeat forms of cultural expression, I recoil from the notion of art by consensus. If creation has to appeal to a common denominator, it is bound to be dull or normative at best, repressive at worst. As in other efforts to curtail free expression, the city needs to articulate a compelling interest if Guyton is to be silenced—especially on his own property. Instead of hounding him, perhaps the city should draw a line around Guyton's activities, giving him and his supporters an opportunity to buy out the immediate neighbors and letting him get on with his work.

Some larger benefit might yet come of it. There is a precedent for the idea that Guyton's project might become a focus for community life. Los Angeles has created an arts center in association with the Watts Towers, and a private foundation, with city help, administers the Orange Show. Houston's cultural life is much the richer for the existence of the Orange Show Foundation: it hires neighborhood kids to help maintain the project, offers art classes and residencies for artists, and sponsors the annual Art Car Parade, an armada of outlandish vehicles that invades the city one Saturday morning each April and has got to be the nation's most amazing show on wheels.

Call me a Pollyanna, but if art is valuable at least in part as the inspiration for communication across the frontiers of class and race, then Guyton's work is fabulously successful. Someday, if it happens, I'll be sorry to see a project born as an artistic and political manifesto

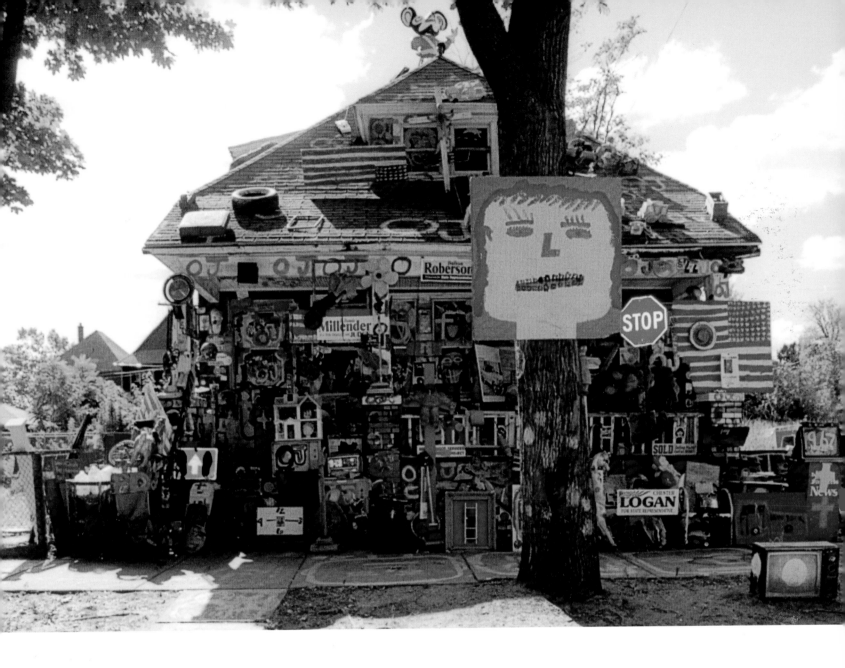

grow into a mainstream amusement. I might then be willing to see Guyton pack his suitcases—and all his other stuff—and move on. In the meantime the cultural conditions that created the Heidelberg Project remain largely unchanged. Keep on, Tyree Guyton. ●

John Beardsley is a senior lecturer in the Department of Landscape Architecture at the Harvard Design School. He is the author of several books on art, including *Earthworks and Beyond: Contemporary Art in the Landscape* and *Gardens of Revelation: Environments by Visionary Artists.*

"Art or Eyesore" was originally published as "Eyesore or Art?" *Harvard Design Magazine* (winter/spring) 1999.

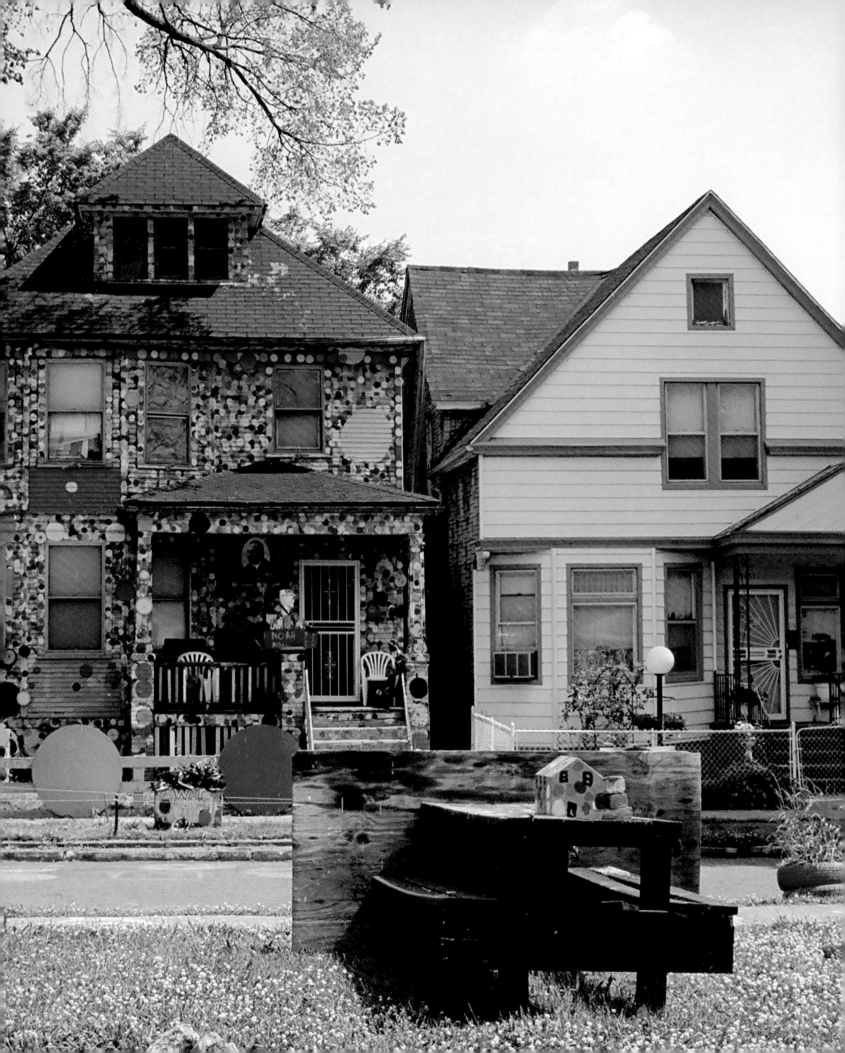

MICHAEL H. HODGES

HEIDELBERG AND THE COMMUNITY

◀ Dotty Wotty House, 2005. JENNIFER BAROSS.

The house at Elba Place and Mt. Elliott Street is covered—virtually wallpapered—with stuffed animals, their cheerful colors bleaching over time toward gray. Look up, and some of the animals are smiling at you. The house marks the northeast rampart of the Heidelberg Project, the idiosyncratic artwork covering more than a city block on Detroit's East Side that some call genius and others say is common rubbish, pure and simple.

The artist, of course, is Tyree Guyton. But never mind. It's Donna Marie McGaughey who takes a proprietary interest in the abandoned house and the artwork on it, and she marches right over the minute she spots two people stopped in front one cold January day. McGaughey's appointed herself the cop on the beat for this particular installation, and she stoops to pick up a teddy bear that's fallen and set it, sitting upright, on the structure's listing front porch—all the while eavesdropping without appearing to interfere.

McGaughey is a short white woman with freckles covering her wide face. A vertical dent creases her left eyebrow, a souvenir from her days, she said, as a hooker in Ypsilanti. She likes and admires Guyton. A large blue polka dot—Guyton's signature image—hangs proudly on a dead tree in front of the shattered house on Mt. Elliott that McGaughey and her common-law husband share, jammed into one bedroom, huddled around the space heater.

"Tyree's claimed me and my husband as part of the project," McGaughey says and puffs up a little. She's thirty-nine, but her voice has a girlish ring to it. She's earnest and likable and broke as a just-robbed bank. The artist on occasion pays the couple to do small jobs. Her husband finds stuffed animals for Guyton. The two also clean up after some Heidelberg gatherings and parties. McGaughey, a little star-struck, once gave Guyton some poems she'd written about him, but that was the last she heard of them. Still, she's fiercely loyal. Of the controversy and considerable opposition to the artist's installations that's raged for years, McGaughey just shrugs. "They're jealous. They look at it like it's a piece of shit. But it's art."

It's small wonder that the Heidelberg Project has aroused deep passions, located as it is along the fault line of race and class in America. Locals often loathe it. The word that gets tossed around is *embarrassing*. But visitors, affluent white suburbanites in the main, go nuts over it. The arguments pro and con have all been made before. But beneath the familiar

words run darker currents touching not just race and class but murkier questions of belonging—questions of who's an outsider and who is not, who is welcome where, and who ultimately profits by the presence of this shambling open-air museum in the midst of a decaying city neighborhood.

Indeed, twenty years on, it's fair to ask whether the Heidelberg Project has improved the neighborhood and helped its community. With the clear majority of neighbors either indifferent or hostile, what claim can Heidelberg make to community enrichment, a central part of its professed mission?

Jump back twenty years. From the opponents' point of view, one day you're minding your own business in a neighborhood undergoing a slow downward slide, when suddenly this self-proclaimed artist announces he's going to make a difference by gathering junk—pure dumpster trash—and stapling it to abandoned houses and erecting it on the sidewalk and in vacant lots. Bad enough, they grumble, that the area is no longer an enviable place to live. Now there's some jackass fetishizing the very decay we're struggling against.

Their sense of expropriation is palpable, and mostly turns on the logic of property rights.

He had no right.

Who told him he could do this?

Did he ask? Did he?

Erma Dicus is seventy-one and lives three doors west of the Guyton household on Heidelberg. She and her husband, Virgil, eighty-two, moved here in 1956 and raised eight children in the foursquare house that now enjoys an unobstructed view across the street of *Many Faces of God*, an installation of several dozen upright car hoods, each sporting a grinning, primitive face. Today is January cold, so the Dicuses are not on their front stoop. They are sitting indoors, halfway up their stairway, peering through the banister to talk to a reporter in the hallway below. Erma does most of the talking.

"I knew Detroit when it was really beautiful," she says. "Oh! It was really nice." She shakes her head, turning over a memory with a half smile. "If people would just do the right thing," Dicus adds, her expression hardening, "it could be nice again"—a hoped-for resurrection that clearly will not include any vacant lots filled with upright vacuum cleaners, gloves

waving whimsically from their handles. She doesn't care how much that artist mows the grass and sweeps the street, which he does, religiously.

Of Guyton, whom she remembers as a little boy running around, Dicus musters only resentment. "Who gave him permission?" she asks, voice rising inside the house with the bleached red-plastic geraniums blooming in snowy window boxes outside. "Who let him do this? It's so ugly. They took some away," she says, referring to the 1999 demolitions during the administration of Mayor Dennis Archer, eight years after Mayor Coleman Young bulldozed three houses within the project, "but now it's come back. Nailing stuff to those trees." She shakes her head. "Some of those trees are dead. That's no good. It's dangerous." Her eyebrows arch and she peers over the banister. "There's *lots* of dangerous stuff there."

"WHAT IN THE HELL ARE I GOT SO ANGRY LAST

The current administration of Mayor Kwame M. Kilpatrick seems to have opted for a policy of benign neglect toward Heidelberg. The mayor has praised the project publicly on a couple occasions—he calls it "artwork that is unique to Detroit"—but otherwise has taken no actions either negative or positive.

Everyone in the opposition chants the same mantra: Would you want it in your neighborhood?

Slice it how you will, the moral knot at the heart of the Heidelberg Project is that it is an act of individual appropriation—yet one undertaken in the name of community, the very community that, if one means the neighbors most directly affected, mostly hates it. The truth is that Heidelberg's popularity seems to increase the farther you live from it. Europeans are *nuts* about it. And locally, it's no secret that the most enthusiastic supporters oftentimes live across Eight Mile Road, the iconic highway that divides the largely African American city of Detroit from the mostly white northern suburbs. Indeed, the startled faces in the cars winding down Heidelberg in the summer appear, anecdotally at least, to be mostly white. But locals tell dif-

ferent stories, depending on their opinion of creator Guyton. Those who love the project—like artist Tim Burke, who moved into a bright-orange house right in the middle precisely to be surrounded by Heidelberg—insist that lots of area residents walk or drive through in the summer, treating the nutso block very much like a public park. But opponents, at least those who are neighbors, almost universally sniff that the only people who visit are "outsiders." It's hard to know where the truth lies. Each side appears to recognize the propaganda value of claiming that this group or that constitutes the majority of visitors.

In appropriating empty lots and abandoned houses for his own flamboyant uses, Guyton seems to have usurped what amounts to a sort of community commons. Listen to the outrage in opponents' voices, and it's almost like they've suffered a tangible loss, as if the

SUMMER THAT I SAID YOU LOOKING AT?"

abandoned structures and empty lots in question had reverted back to the community at large on a co-op basis and they've been cheated out of their share. Of course, any substantial change likely would have aroused resentment. But what really sticks in their craw is that Guyton didn't initially own most of the property he "improved," nor does he even live there. (His mother lives on Heidelberg in the house Guyton grew up in, but the artist himself lives on the city's West Side.) Lately, the Heidelberg Project has acquired title to eight city lots and four properties in the area, according to Guyton's wife, Jenenne Whitfield, who serves as the project's executive director. But that fact isn't necessarily well known among opponents—or regarded with much interest if it is. As far as they're concerned, Guyton's still squatting on other people's property. Their property.

The property in question forms part of U.S. Census Tract 5168 in Wayne County, Michigan—an isosceles triangle comprising fifty blocks defined by Waterloo Street on the south, Mt. Elliott on the east, and Gratiot Avenue slanting across the top to the northeast. The impression that this is a distressed neighborhood is underlined by the numbers. The 2000

census found that residents were older than average and that almost half of all households included someone older than sixty-five. A quarter of the households earned between $15,000 and $24,000 a year, while one-fifth brought in less than $10,000. Twenty-eight percent of families fell below the poverty line, but that rate jumps to 33 percent if there's a child under eighteen present. Add a child younger than five, and the rate hits 49.2 percent.

Householders, as least those who own their property, are mostly stuck. Both the census and a local real-estate appraiser, Jack Johnson, put the value of houses at about $10,000. And where are you going to go with that—if you can get it? In any case, uprooting in the suburbs is a more casual affair than on Heidelberg, where generation after generation has grown up in the same house and all filed through the doors of nearby Bunche Elementary—an attachment to place common to urban African American neighborhoods but otherwise unique in American life. Consider Sylvester Jackson, who's lived in her house a block from the project since 1954. And Lucile Lewis, also on the second block off Mt. Elliott, who moved to the area fifty-two years ago.

Glyenn Whiteside, a community activist and longtime opponent, calls the neighborhood mostly working class. Much of it is tidy in a run-down way, the landscape only occasionally punctuated by a burned-out husk of a house. But pockets of poverty grab the onlooker by the lapels. Empty lots, of course, are everywhere, since many decrepit houses—most famously on Heidelberg—have been pulled down by the city in the past decade. The resulting emptiness gives the area the feel of a small, country town with abandonment issues.

Those who've fought the Heidelberg Project over the years—whether picketing with signs reading "This is garbage!" or angrily declaiming in front of the city council—say the project has not only made a trash heap out of the principal block but also, because of the attention it draws, radically changed the character of a once-quiet enclave.

Behind the Guyton family household on Benson Avenue, B. B. Odums, a city employee who says she's lived her whole life in the surrounding neighborhood, rails at the loss of privacy she says the project has visited upon neighbors—and the political injustice wrapped up in that.

"If we rode up and down the streets in the suburbs," Odums said, "we'd get picked up

because we're black. Every summer night we've got people riding up and down and looking at what we're doing. It's an invasion of privacy. They look at us like we're animals on display. I got so angry last summer that I said, 'What in the hell are you looking at?'"

Odums's remarks echo reservations on the part of Bamidele Demerson, curator of exhibits at Detroit's Charles H. Wright Museum of African American History, who worries that visitors may simply see Guyton and his neighbors as "exotics"—a word freighted with colonial and exploitative associations.

But Lucile Lewis, the seventy-six-year-old retired school bus driver, just laughs. "Shucks," she said of the visitors, amusement coloring her voice, "they wave at me, I wave at them. Everyone doesn't feel the same way."

Real-estate appraiser Johnson, a former army guy who lives nearby, turns the accusation back at critics like Odums. Johnson freely admits that he fell in love with the project the first time he visited. He's heard the complaints that "white people come down and take pictures of us and treat us like monkeys," but he's not buying it. As far as he's concerned, neighbors have no basis for criticism until they clean up their own acts. "You say the Heidelberg Project is raggedy or an eyesore," he says, "but what are you doing in your neighborhood? If people are taking pictures, maybe you should paint and clean your gutters or mow the lawn or not let the dog shit on the front porch. It's a whole mentality," says Johnson, who's black and grew up in the Deep South. "Until we actually start changing the mind-set, we're just rearranging deck chairs on the *Titanic*." Sour neighbors, Johnson contends, resent Guyton because, against all odds, he accomplished something—"and reminded them of their failures."

Any accounting of Heidelberg's net contribution to the community has to consider the project's work with kids, most of whom take to it like ducks to water. Guyton runs an annual summer program, Art in the 'Hood, that in 2005, according to sixteen-year-old student mentor Melissa Davenport, drew a couple of dozen enthusiastic seven- to twelve-year-olds for the two-month term. And Phyllis A. Lovette, principal at Bunche Elementary, will tell you in no uncertain terms that without Heidelberg—whose representatives are in her building twelve hours a week—students would receive no art instruction whatsoever. The project has

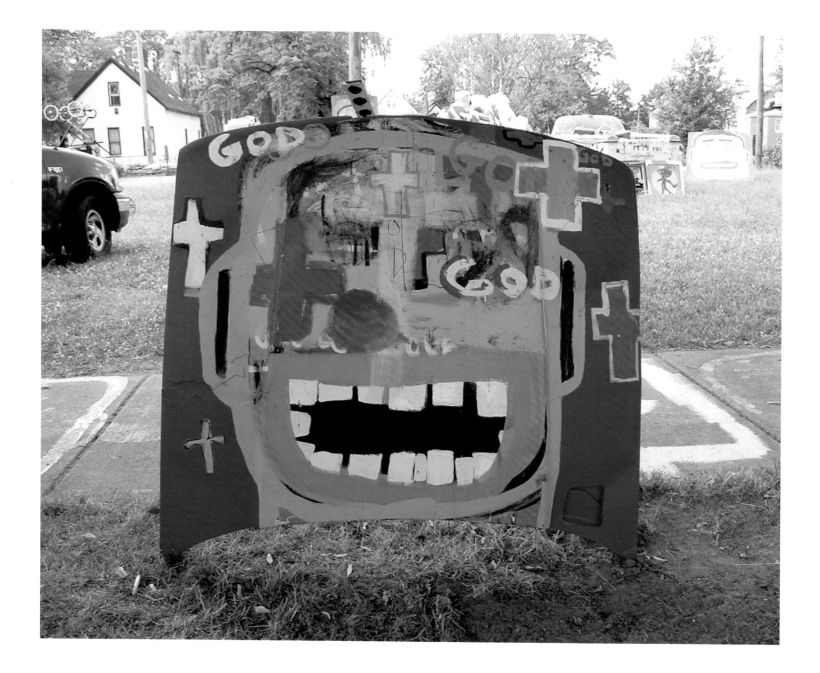

reached out to other Detroit schools, as well as a number of suburban districts like West Bloomfield, where Guyton worked on a couple of projects with art teachers and students, including an assemblage of sixteen hundred decorated shoes—each with a message inside from the child—that went up at a busy suburban intersection on Martin Luther King Day, 2006. The kids, says Christy Forhan, mother and chair of the Art Smart Committee at Scotch Elementary, "treated Guyton like he was a rock star."

Still, it's at Mt. Elliott and Heidelberg that the project works its most remarkable—indeed, almost unprecedented—magic, in its uncanny ability to melt suburban apprehension about down-at-the-heels black neighborhoods. John George, whose nonprofit Blight Busters

Leroy, paint on aluminum, 61 x 58 in., Faces in the Hood series, 1999–2004. HEIDELBERG ARCHIVES.

fights dilapidation throughout the city and who has worked with Guyton, can't put it baldly enough. "You see the suburbanites cruising through," he says, "cameras snapping, everyone's eyes as big as saucers. And then they pull over and actually get out of their cars.

"I mean," he says, spacing his words for emphasis, "*this is the middle of a friggin' ghetto!* Talk about a marketing tool!"

Heidelberg and its partisans tout such visits across the racial and economic divide as proof positive of the benefits that the project is supposedly bringing to the neighborhood, as if visits by foreigners and suburban outsiders constitute a tangible, measurable good. The project, they always say, is bringing people together, reaching across the trenches that divide city from suburbs, black from white. By an accident of timing, I conducted research for this essay in the dead of winter, when few tourists are found wandering the polka-dotted street. And, frankly, winter is bleaker on Heidelberg than most streets, when lead-gray skies and celery-colored grass suck the life and humor out of Guyton's assemblages, and everything just looks weather-beaten and sad.

It's summer when Detroit's most flipped-out block really springs to life and conjures its fizzy, oddball seduction. Two examples from a week spent hanging out with Guyton ten years ago for a newspaper profile illustrate the point. On a fine afternoon in June two well-dressed women and a little girl from Grand Haven wandered through Guyton's crazy-quilt landscape. In Detroit just for the day, they had swung by Heidelberg, Hazel Christiansen said a little proudly, because her

granddaughter, Claire, nine at the time, was something of a "modern-art connoisseur."

Claire's blue eyes were bugging out, and you could see the fillings in her teeth. "We've got a guy who writes on his house in Grand Haven," she said, almost gasping, "but this is *way* cooler."

A couple days later dozens of Ann Arbor sixth graders from Tappan Middle School crouched on Heidelberg itself, earnestly polka-dotting under Guyton's direction. Paintbrush in hand, Jonah Rusling conceded that he was a little freaked out when the bus first arrived.

"I was sorta scared," he said softly. "Ghetto and stuff."

"But it doesn't feel ghettoish," added Bill Loesel. "It's nicer than that."

Would they want this on their own blocks back home?

In unison: "Sure!"

For at least some visitors, something more potent than just art appreciation appears to be going on. The sunniest interpretation is that Heidelberg may allow some white middle-class sorts—apprehensive about the city, feeling unwelcome in black neighborhoods, and yearning, for one reason or another, not to feel these divisions so acutely—to experience a sort of Disneyfied connection to the 'hood.

Assume, for a second, that visits like those do have merit, that Heidelberg encourages forward progress among at least some of its white visitors, who somehow leave with prejudices softened and horizons *American Worker*, Faces in the Hood series, 1999–2004. HEIDELBERG ARCHIVES. ▶ widened. The question that arises, then, is this: Is the local community of mostly ticked-off neighbors being sacrificed to a higher good? Is their annoyance and sense of dispossession balanced by the advances, however shallow or halting, that some white visitors might be in the process of making? Indeed, is it right that one's quiet home life be sacrificed to a collective therapy session for needy white suburbanites?

Nettie Seabrooks, who held a variety of top jobs under Mayor Dennis Archer, dismisses trips across Eight Mile Road to visit Heidelberg as just so much "artistic slumming. Like going to the Cotton Club years ago in Harlem. 'Oh, I'm not a racist. I go down to the Heidelberg Project.'"

Longtime opponent Whiteside, who's vice president of the local McDougall-Hunt

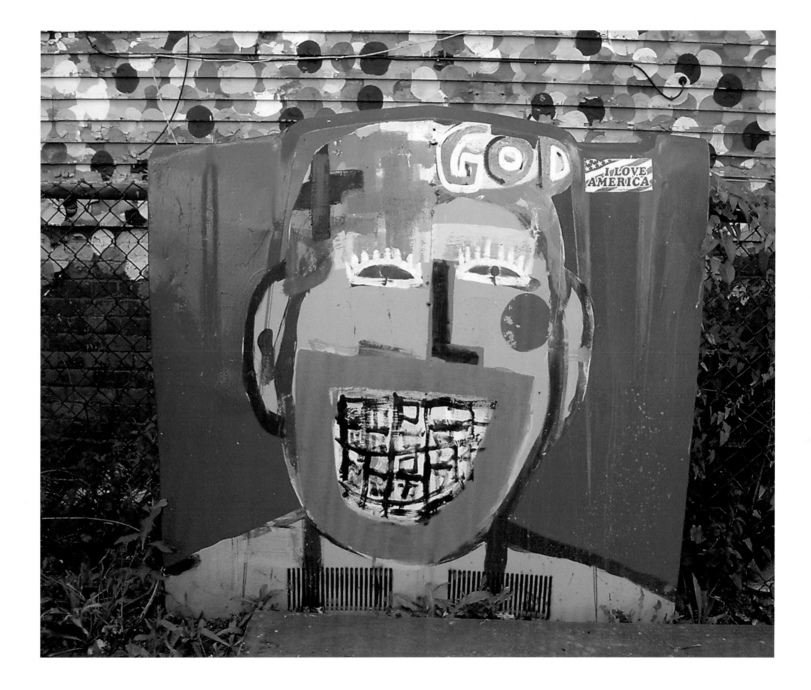

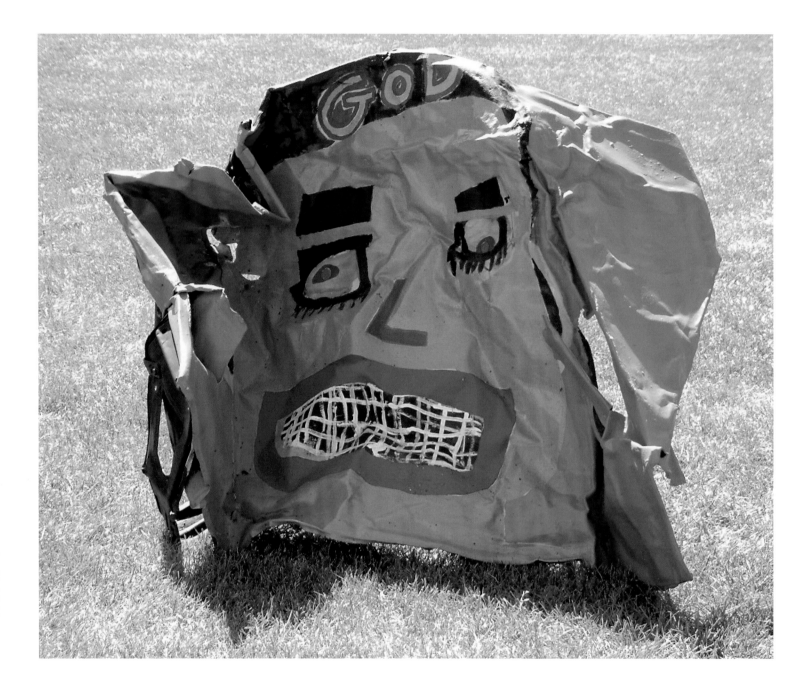

Citizens' District Council, which has tenaciously fought the project for years, argues that Heidelberg amounts to a sort of bubble, a cocoon that—appearances notwithstanding— mostly isolates visitors from contact with the community. She acknowledges that local children often hang out on Heidelberg but says it's rare to see neighborhood adults walking around and talking to visitors. "So I don't know how much goodwill it's bringing about," she says, adding that the tourists rarely wander off that one block. "I don't see where there's a real effort to bring the community and visitors together. I just see it as a self-interested thing on the part of the Heidelberg Project." As for white visitors' stepping out of their cars in a "ghetto" neighborhood, Whiteside is unimpressed and scornfully imagines that they think they've really done something big and brave—"like visiting a foreign country," she says, "and coming out safe."

Like Odums, Whiteside resents the invasion of privacy. "It's insulting and intrusive to suppose that, because we live in the project," she says, "you have a right to speak to us, much less pick up somebody's grandchild. It's been my impression that people who live here are taken to be part of the project itself. It becomes real personal."

But Agu Nwosu makes a sort of baby-steps argument on behalf of outsiders. "Maybe the experience is a doorway," said Nwosu, who grew up in Detroit's Palmer Woods and now

Life Is Good, Faces in the Hood series, 1999–2004. HEIDELBERG ARCHIVES. manages a nightclub in Royal Oak. "You can come and just drive by. Or maybe explore. You drive through and you may feel some sort of glow, but I'm not sure that takes away the sense that, 'Oh my God, this neighborhood is terrible.' I'm not sure it takes away the sadness. I think it puts it in a context where we can start to look at it, and maybe start to deal with it. That's the beauty of art. In some ways we may be able to detach ourselves from things that may be too real or too potent."

All the same, Nwosu can understand the resentment at having leering outsiders pour through your neighborhood, cameras flashing. "I can see the neighbors thinking, 'What are all these white folks doing down here?'" Nwosu says. "'And they're reaching over and picking up my kid.' Or whatever. I can see that side of it. But I can also see people coming down, they were in the 'hood, and had this really great experience with this really cool black guy. And that all has value. It is bringing people together. I can sit here and wish we had a better forum or bridge, but I haven't built one. This is live. This is action. It's got a life of its own."

You can almost hear Seabrooks shaking her head over the telephone line. Visiting Heidelberg, she says, "reinforces existing views of the city." She concedes that non-Detroiters "may get out of their cars and walk around, but then they get out of that area as quickly as they can."

But state senator Hansen Clarke, who's a big supporter and represents the Heidelberg district in Lansing, maintains that after decades of losing residents to the suburbs, all visits by outsiders are ipso facto good and helpful. As to whether such forays merely underscore

IT'S GOTTEN PEOPLE WHAT'S GOOD FOR THEIR SENSE WHETHER THEY IT'S BROUGHT THEM

existing prejudices, Clarke shrugs off the idea that Detroit is something visitors need to be shielded from. "The city is what it is," he says.

Amy Milligan, who first visited in 2005, agrees that the neighborhood isn't one she'd ordinarily feel comfortable in—even though she's got relatives in Detroit—but notes the power that Heidelberg has to unravel such fears. "I didn't feel unsafe at all," says the Northville resident. "It's like this little oasis in the desert, with this glimmer of—I don't know if I'd use *beauty*—but something out of the ordinary, something challenging."

At the University of Michigan, Scott Kurashige, an associate professor of history and American culture who's written widely on racial issues, thinks a self-selection mechanism is at work that filters out most visitors who are hostile to the city. Of those who do come, he says, "My sense is this is a block of people who are rooting for Detroit, whether because of white guilt or paternalism or political commitments or whatever. It may be an armchair experience, but Heidelberg becomes a way for them to cheer for this underdog story.

"The people who are mad at Detroit," he adds, "are not the ones, I think, who find Heidelberg groovy. I don't think those people are saying, 'Oh, but I love Heidelberg.'"

The cynic might say that, once again, it's all about the white folks—a little like such ostensibly African American films as *Glory,* where the story focused on the white guy in order to sell tickets. Still, in a society as racially fractured as this one—and in an environment in which, by and large, whites hold all the cards—suburban attitudes can have real impact on black neighborhoods like Heidelberg. New Yorkers hooted up a storm in the 1980s when

THINKING ABOUT COMMUNITY. SO, IN A LIKE IT OR DISLIKE IT, TOGETHER.

then-mayor Ed Koch pasted cutesie "window" scenes, complete with curtains and vases of flowers, onto the empty windows of the abandoned housing projects that line the Henry Hudson Parkway coming into Manhattan. But Koch always maintained that suburban attitudes spell life or death for the city—and that faking them into thinking things were on the mend could have a positive payoff for New York.

Which circles us back to asking whether Heidelberg has contributed in any material way to its professed goal of building community, particularly among that population closest to the principal block, for whom the project is unavoidable and unforgettable. Three blocks away at the Franklin Wright Settlement, a social services nonprofit, executive director Monique Marks, a cheerful woman in dreadlocks, argues that Heidelberg has clearly brought neighbors closer, though not in the way one might think.

"One thing it's done for the community," she says, "is give them something to talk about. It's gotten people thinking about what's good for their community, so, in a sense, whether they

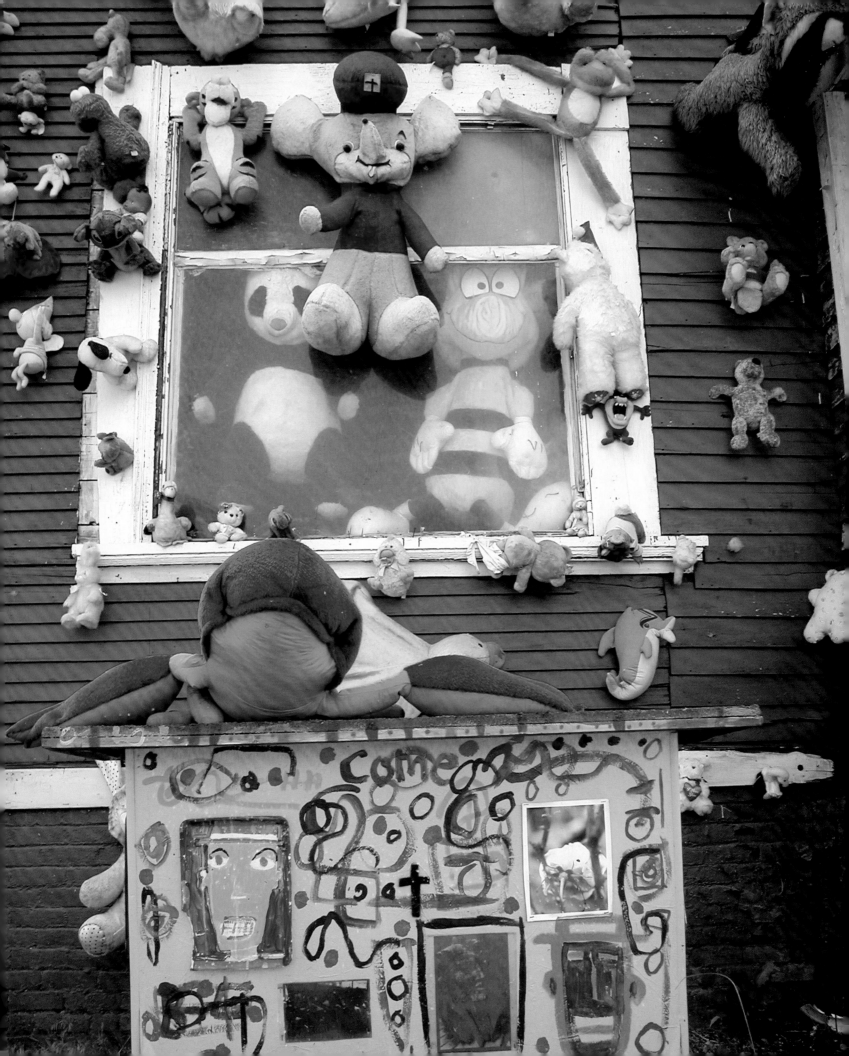

like it or dislike it, it's brought them together." Meetings with city council members to discuss the issue are always mobbed, a welcome respite, she suggests, from the hopelessness that blankets other neighborhoods.

But Whiteside turns this argument on its head. Whiteside, who lost her childhood home on Detroit's Hastings Street when the city rammed the Chrysler Freeway through, now sees a different, but no less potent, destruction at work in her adopted neighborhood. The project, she feels, has undermined the district and scared off potential redevelopment. And, she adds, the long fight has knocked the stuffing out of a lot of the residents—a little like the deflated stuffed animals piled in a heap across from the Polka-Dot House.

After the 1999 Archer demolitions, she says, "I think the community finally got the sense that they had a little bit of a voice in their neighborhood. But it didn't really last. The bulldozers retreated, and the project rebounded." She sighs. "So it's back again. And the community is back to, 'Well, what difference did that make?'" The upshot, she suggests, is to reinforce a corrosive sense of futility and dispossession.

Party Animal House, 2005. JENNIFER BAROSS.

Happily, such hair splitting is immaterial to Justin Woods-West, twelve, who grew up on the block and whose entire life has been framed by Heidelberg's baby dolls and polka dots. As he puts it with a quick smile, it's all he's ever known.

Walking the neighborhood with Justin, who's got the rangy stride of the taller guy he's growing into, you begin to realize what a small town this really is. A maroon car slides up beside us on the street, and Justin exchanges a few words. The car sails on. "That's my big brother," he says, a little proudly. "He's always checking up on me." He waves at another car. The folks inside wave back.

When he rounds the corner onto Heidelberg, he's promptly set upon by two matter-of-fact cats and a gleeful pit bull named Diamond. Justin walks the street like he owns it, pointing out the creations in which he participated, like the dozen bright doors, all leaning one against the other, that he helped repaint last summer. He has appreciative comments for resident artist Burke's installations as well, especially the three charred timbers anchored in cement and standing twelve feet tall, which he says represent the crucifixions on Calvary. And the elm tree across the street, dripping sneakers like exotic seed pods? "Souls in heaven,"

he says. It's not clear if he gets the pun.

Justin grew up in the Polka-Dot House with Guyton's mom, whom he calls Grandma, even though she's not a relation. He has dim but disturbing memories of the house next door's being razed by the city. That was seven years ago, when Justin would have been about six. He thinks he remembers bulldozers. He's not sure.

The intensity of the opposition baffles the young man, since the project is a source of unending delight for him. But he knows that however peaceful things look right now, the artwork is always under threat of extinction. Were it to go, gone too would be the happy after-noons hunting down car hoods with Guyton or earnestly Polka-dot protest, 2000. HEIDELBERG ARCHIVES. ▶ repainting polka dots on the asphalt pavement. The possibility that the enemies of Heidelberg might one day win is one that Justin's clearly considered but filed under Not Going to Happen.

"If they tore it down," he says, "I'd go berserk." ●

Michael H. Hodges has been a feature writer at the *Detroit News* since 1991. Before that, the native Michigander—Hodges grew up on a dairy farm thirty miles north of Detroit—worked at the *New York Post* and the *Caracas Daily Journal*. His work has also appeared in the *New York Times, The Nation, Details, Spy,* and *Out.*

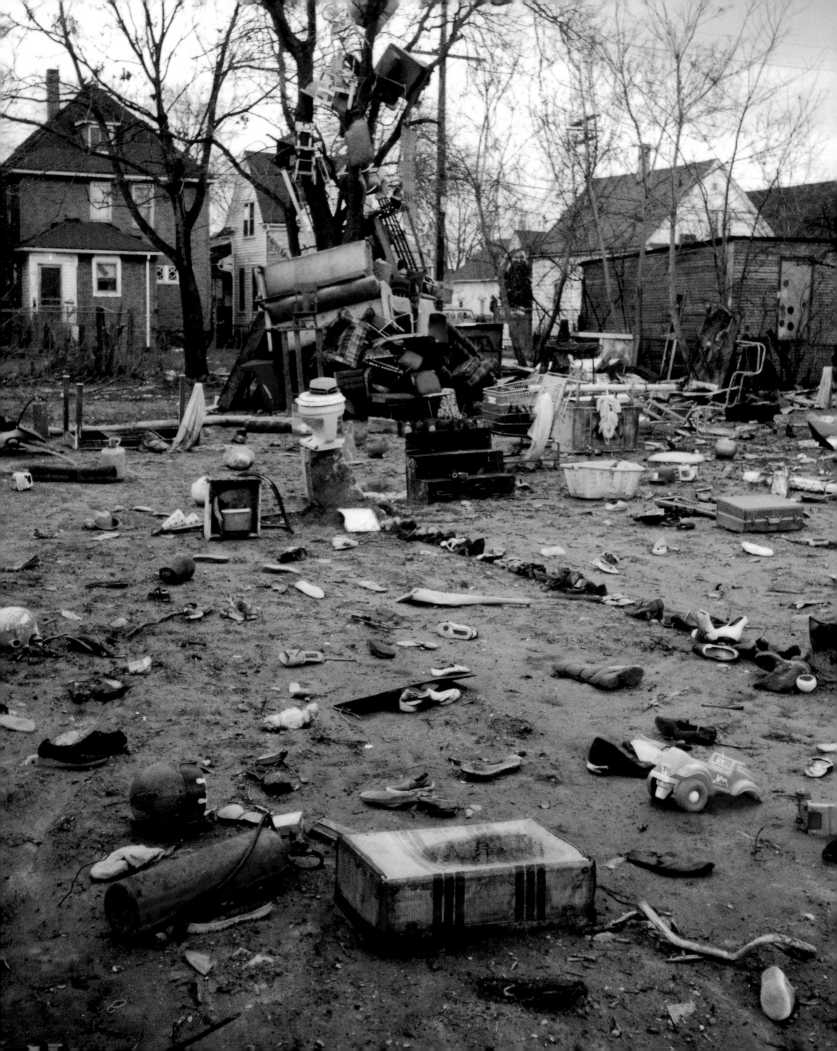

HEIDELBERG AND THE CITY

MARILYN L. WHEATON

◀ Relics from the 1991 demolition. HEIDELBERG ARCHIVES.

n 1967 race riots set Detroit ablaze. "I was 12, and I thought the world was coming to an end," Tyree Guyton recalled for the *Kalamazoo Gazette* in September 2005. "Everywhere I looked, buildings were burning. The city never recovered. We're living in a new millennium and we're still not recovered."

For nearly two decades after the riots, parts of Detroit's East Side continued to decline. Abandoned and burned-out homes and buildings, and vacant lots filled with tall weeds, were taking over the Guyton family's neighborhood. Prostitution and drug trafficking increased. It appeared that no one cared.

In 1986, when Tyree Guyton was thirty-one, he realized that city government had abandoned his side of town, his neighborhood. What had happened was plain for all to see: the decay and devastation of poverty and abandoned buildings. Guyton is quick to point out that, at that time, city government had no plans for the neighborhood. Its residents didn't know what to do, either. It seemed clear to Guyton that the government had failed its citizens.

Anyone who knows Tyree Guyton knows that he is neither passive nor patient when it comes to the environment in which he lives. Guyton's desire to have his neighborhood rise from the ashes, to be beautiful and safe, met with the urging of his grandfather Sam Mackey to empower himself. Guyton loved, respected, and believed in his grandfather. Mackey understood, as most artists do, the power of a paintbrush and canvas. He also understood that you don't need a fabric canvas on which to paint. Your canvas can be any object, any place. He instilled those beliefs in his grandson.

Guyton said he "had a divine vision" in 1986. "I was standing in the doorway, looking outside, looking at what was there. There was nothing, at first. And then I decided to take nothing and transform it into something incredible" (*Kalamazoo Gazette,* September 2005).

He began to paint multicolored polka dots on vacant houses in the neighborhood and on the streets. Discarded objects (car hoods, houses) became Guyton's canvases.

Within a few months the block on Heidelberg Street between Mt. Elliott and Ellery was filled with shoes, baby dolls, and stuffed animals hanging from trees, houses painted with polka dots and numbers, and abandoned lots filled with row after row of discarded vacuum cleaners and other appliances. A public work of art was in the making. Guyton had no way

of knowing, then, that his expression of hope for his neighborhood and the city he loved would become a political football for the next two decades.

Although prostitution and drug dealing seemed to decrease as Guyton's creation attracted local, national, and international media attention, many city officials could not relate to and did not understand or appreciate what he was creating.

The Heidelberg Project's worst nightmare began in 1991, when city hall began to notice all the attention paid to Guyton's public art project on Heidelberg Street. In the years since, city officials have seldom been able to decide for long whether they support or hate it.

For example, in 1989 Guyton received the Spirit of Detroit Award from the city council for his beautification efforts on Heidelberg Street. Two years later the *Detroit News* honored Guyton as a Michiganian of the Year. That same year, 1991, Mayor Coleman A. Young sent bulldozers and wrecking balls to Heidelberg Street in the stealth of darkness to demolish the public art project. Guyton had fifteen minutes to save whatever he could. Artists and supporters of Guyton and the Heidelberg Project were outraged and, when they heard about the demolition, began to make their way there. Too late to do anything about the demolition, they stood strong in their support and friendship for the artists as they watched five years of Guyton's and Mackey's art be taken away in a few minutes.

Some people believed that Mayor Young did not feel comfortable having suburbanites and tourists drive through blighted and burned-out Detroit neighborhoods to see the Heidelberg Project. Perhaps it reminded him too much of the pain and sorrow so many Detroiters experienced during and after the 1967 race riots, and he just wanted the reminder to go away. Many people said he was embarrassed by it. I don't know if anyone ever really understood why Young sent the demolition crews in to destroy Guyton's and Mackey's work.

Yet in 1994 city council president Maryann Mahaffey was a guest speaker at the Heidelberg Project's first street festival. Two years later I joined Mayor Dennis Archer and many other Detroiters in donating shoes for a project in St. Paul, Minnesota, where Guyton had been invited to create a "shoe house" titled *Soul People . . . How Beautiful Are the Feet of Them Who Carry Glad Tidings*. More than four thousand pairs of shoes were nailed to a two-story house that was home to a longtime resident of St. Paul's Frogtown section.

In the spring of 1997 the Heidelberg Project was awarded a $47,500 grant from the city's Cultural Affairs Department for the development of a jazz café and welcome center. It would be a place where visitors to the project could stop to have a cup of coffee or tea and a sandwich while listening to recorded jazz and learning about what they were going to see or had seen as they walked through the project.

The Cultural Affairs Department had sought the grant from the Michigan Council for Arts and Cultural Affairs, the state arts council. An important criterion for that particular grant was economic development. Once the first payment was made to the Heidelberg Project, a large sign was installed near an abandoned building a block from Heidelberg Street, at the corner of Ellery and Elba streets, announcing it as the site of the café and welcome center.

Congregation House after demolition, 1999. HEIDELBERG ARCHIVES. ▶

It was the first sign of a revenue-generating facility within the Heidelberg Project and was to be the first step in the project's economic development plan. Archer and the city planning commission had told Guyton and Jenenne Whitfield, the project's executive director, that they needed to get serious about economic development and neighborhood revitalization if they wanted city support

A few days after the sign went up, a small, vocal group representing the local citizens' district council and the Gratiot-McDougall United Community Development Corporation, led by an articulate woman named Janice Harvey, began to make appointments to speak with city council members. They complained bitterly that the residents of the Heidelberg neighborhood were being forced to live with junk—"garbage," they called it. They said their rights as homeowners were being trampled. Their complaints attracted media attention and convinced some council members that the Heidelberg Project was a menace because all the "junk" was attracting rats "as large as cats," and too much traffic.

Naturally, reporters wanted to know the mayor's position on the Heidelberg Project. Archer was campaigning for a second term and had no interest in becoming embroiled in a controversial issue like the Heidelberg Project. He understood that some Detroiters loved and supported the artist and the project. Archer also knew that Guyton had not played by the rules. Some of his art was on city-owned property or on abandoned property that the city

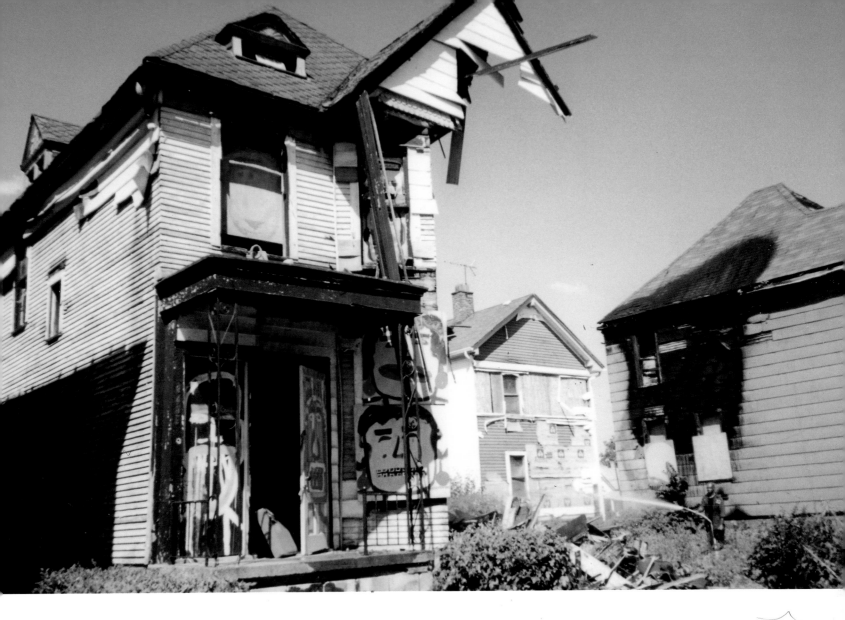

had not yet confiscated for back taxes. Mayor Archer had no animus toward Guyton or the Heidelberg Project; however, because he believed that he should enforce the law, he supported city council's decision to dismantle that portion of the project that was on public property.

By this point the Heidelberg Project was so controversial that the state arts council asked the city's Cultural Affairs Department to return the grant for the Heidelberg jazz café and welcome center. The state council was not interested in supporting such politically controversial artwork or in becoming mired in local politics.

I was director of the city's Cultural Affairs Department at the time, and Archer had asked me to be his liaison to Guyton and the project. I understood his reluctance to fully embrace the project, given that Guyton had not done everything by the book. On the other hand, the

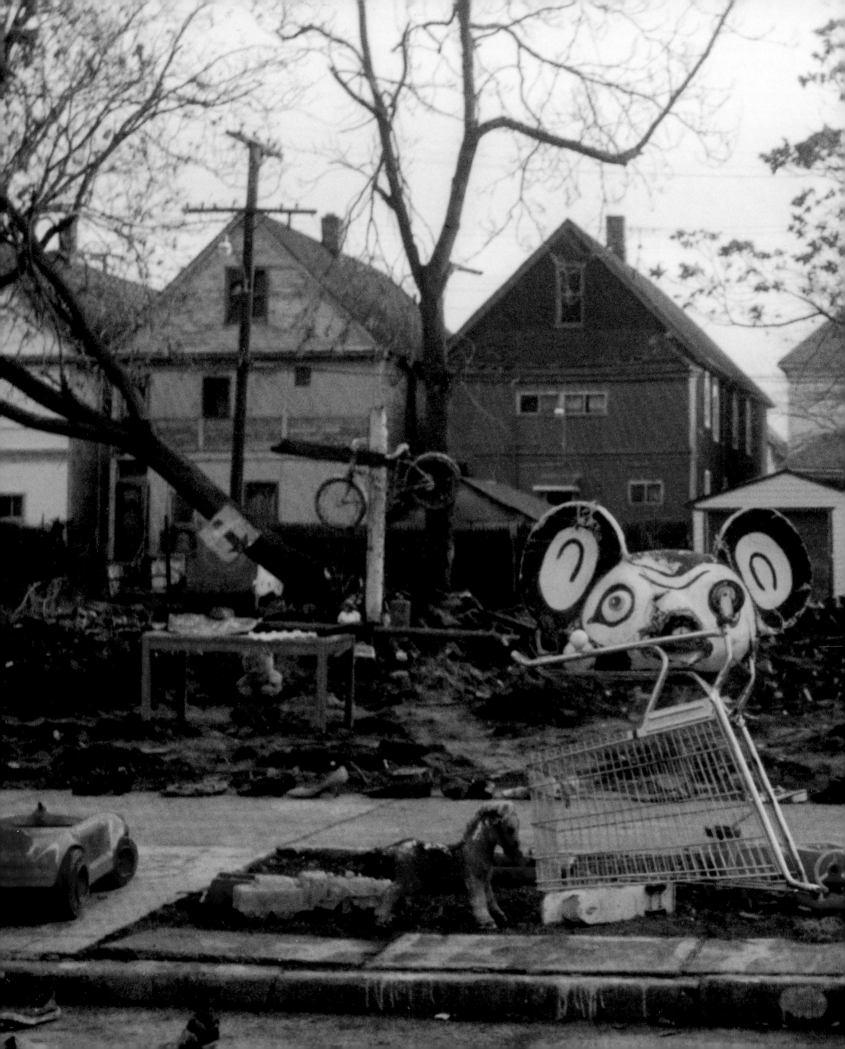

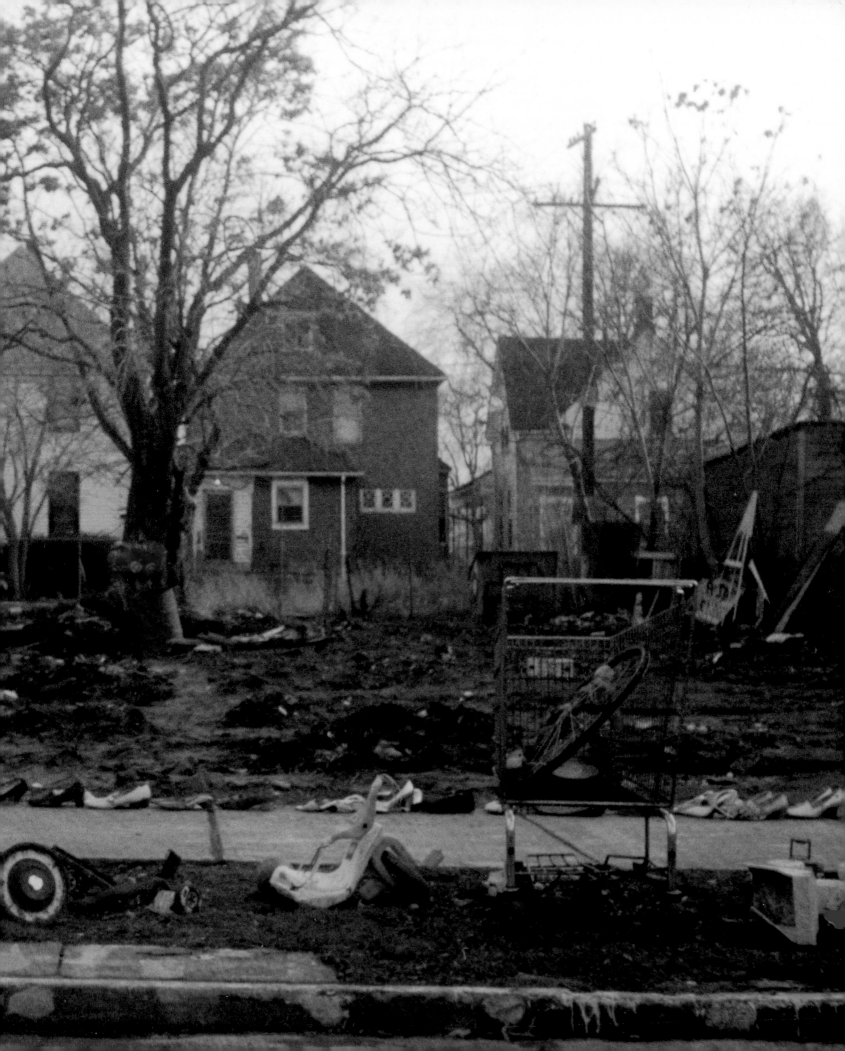

city had done nothing to improve the continuously declining neighborhood in three decades. So why were elected officials so upset that a Heidelberg Street resident and others were trying to do something to bring signs of hopefulness to a blighted neighborhood?

A couple of families who lived on Heidelberg Street, in the block where the project is located, didn't appreciate the busloads of tourists and students and other vehicular traffic the project attracted. Sometimes the vehicles would stop and visitors would get out and walk through the one-block project. Other times the buses would travel slowly down the street, with visitors looking out the windows in awe at what they saw. All those faces, many of them white, made the residents uncomfortable.

In February 1998, city council set an August 24 deadline for demolition of portions of the Heidelberg Project. Attorneys for the project went to court and were awarded a tempo-

I WANT IT GONE. I'D PUT DRIVE THE BULLDOZE IS STILL UP WHEN WE CO

rary restraining order against demolition and requested an extension of the deadline. City council adjourned in August without addressing the extension, and councilwoman Kay Everett was quoted as saying, "I'm not in favor of an extension. I want it gone. I'd put on a hard hat and drive the bulldozer myself, if the project is still up when we come back from recess" (E. Galen, www.wsws.org, August 20, 1998).

In a memo to the city planning commission that year, Clyde D. Dowell, the city's public works director, wrote: "The Heidelberg Project fits the description of an illegal dump site and will be handled in that manner." Councilwoman Sheila Cockrel said of Guyton, "What he has done is art that spoke to realities at a time that it happened, and that has changed."

But had it? In 1998 the Heidelberg neighborhood, located in the McDougall-Hunt district, which is bounded by Gratiot, Vernor, and Mt. Elliott, had not improved. In fact, the

neighborhood was experiencing ongoing decline. According to the U.S. Census Bureau, in 1960 that area had 2,500 housing units with approximately 250 vacancies; in 1990 the area had about 1,000 housing units, 150 of which were vacant; and in 2000 it had roughly 750 housing units, 150 of which were vacant.

As controversy licked the Heidelberg Project once more, I realized that it had become a real conflict of interest for me because I had supported Tyree Guyton and the Heidelberg Project since 1991. I respectfully asked the mayor to relieve me of the responsibility of being the official liaison from the mayor's office to the project.

When the city finally moved on September 21 to dismantle the Heidelberg Project, a large crowd of protesters forced the city to back off. One of the protesters, a homeless man named Johnny Brown whom Guyton had befriended, said, "The city workers came here and

ON A HARD HAT AND MYSELF, IF THE PROJECT ME BACK FROM RECESS.

they just sat all morning. Then they gave Tyree a big hug and left. They didn't want to come here and move anything," wrote Shannon Jones (www.wsws.org, September 23, 1998). The next day a local judge issued a temporary restraining order against the Archer administration.

But her order held for only a few months. In February 1999 the restraining order was lifted, and the city's public works department was back on Heidelberg Street once more, demolishing what had become a hot tourist attraction.

Guyton and people who have come to know and appreciate the Heidelberg Project would tell you that his work is meant to demonstrate his outrage at the social degradation and blight that continues to mark the hometown he loves deeply. If city government wasn't going to get rid of the abandoned houses, vacant lots of weeds and tall grass, drug dealing, and

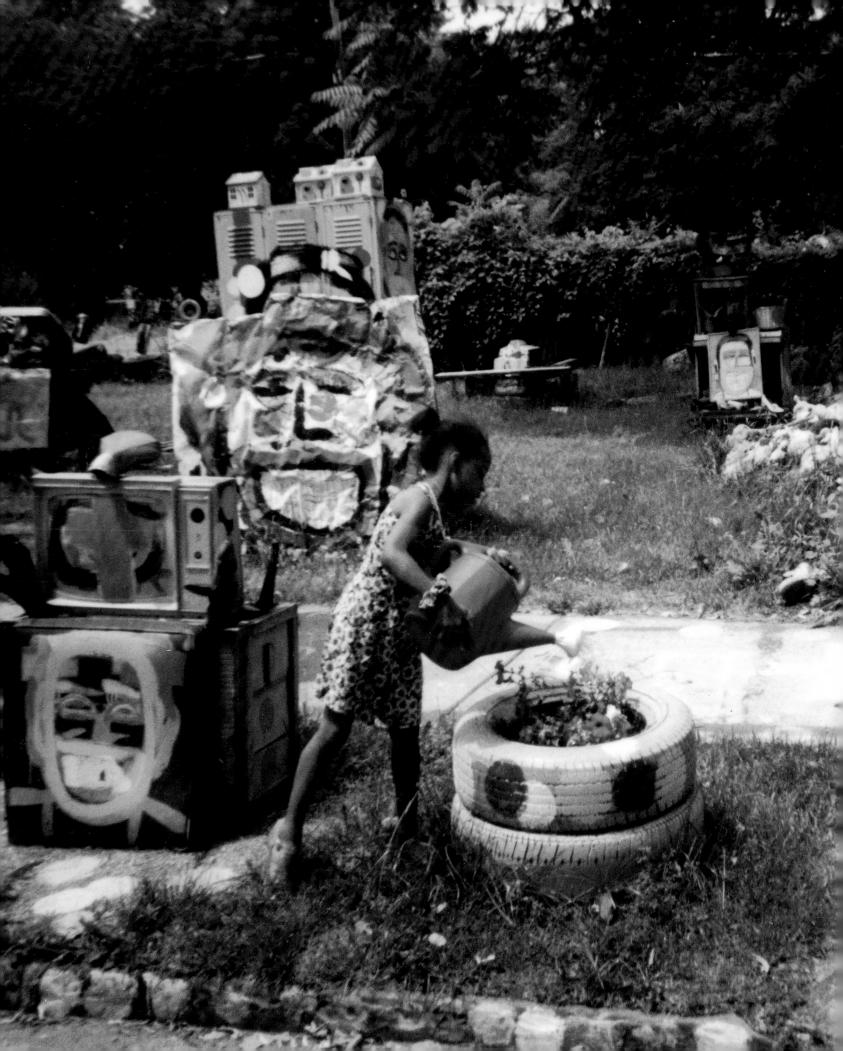

prostitution, Guyton was determined to do it himself. For the most part he's succeeded. He has forced local government to respond to his neighborhood.

In March 2005 a small, vocal group of people from the East Side Citizens' District Council were back before the city council, complaining about the Heidelberg Project, roused this time by Guyton's plans for The House That Makes Sense on Heidelberg Street, formerly known as the OJ House. It didn't, the neighbors said, fit into their development plans for that neighborhood.

On May 27, 2005, ground was broken for a new development at the corner of Hendricks and Elmwood streets in the McDougall-Hunt district, where Heidelberg Street is located. The plan is to build 146 modular homes over five years with financing provided by the city's Planning and Development Department and Housing Commission and Charter One Bank.

For Guyton the Heidelberg Project has always been about neighborhood revitalization. Young people from the neighborhood work with him on art projects. He inspires them to use

Child watering flowers on Heidelberg Street, 1997. HEIDELBERG ARCHIVES. their minds in creative ways. Kids love

Tyree Guyton because he respects them for who they are. He becomes a friend to homeless people who wander over to the project. They would lay down their life for him because he has respected and loved them when no one else did. If Guyton is on the site—which he is nearly every day when he's in Detroit—he greets each visitor as if she or he were the first visitor. These visitors become his supporters and admirers.

Think about it: What better place to come to learn, to meet friends, or just to feel safe than a warm and welcoming street in your neighborhood? Tyree Guyton has become a local hero to many, and the Heidelberg Project has become an "outsider art" enclave where people of every color, age, and educational background have come to experience that which they have heard or read about or arrived at by happenstance. Many people worldwide, including some Detroiters, would say that Tyree Guyton is Detroit's best and most admired goodwill ambassador.

Tyree Guyton is the antithesis of most politicians. While he believes in and values the role of government in a democratic society, he questions the legitimacy of politicians who use their power and positions to wield an ugly stick, especially in election years. Guyton is a

constant in that his beliefs are deep and unswerving, and election years don't affect those beliefs.

Guyton is tired of the politics. He's involved in so many important teaching and educational art projects around Michigan, the country, and the world that he no longer has time to be concerned about the politics. Both Guyton and Whitfield are busy doing the important things in life—sharing their experiences of the power of art in an urban environment with grade school, high school, and university students as far away as Sydney, Australia, and as near as Bunche Elementary School, three blocks south of Heidelberg Street.

If the bulldozers and heavy equipment arrive at Heidelberg Street again, will Guyton exert the same kind of energy he's exerted twice before to stop the demolition? I would bet that he wouldn't. I believe that Tyree Guyton and Jenenne Whitfield understand that the Heidelberg Project is embedded in the hearts and minds of every person who has witnessed it, first- or secondhand, and that it therefore cannot be destroyed by politicians, natural disaster, or any other force.

In June 1997 my parents were in town from Missouri, attending an annual reunion of navy veterans who served on the aircraft carrier *Essex* in World War II. When they finished touring downtown Detroit and were ready to head back to their hotel near the airport, the tour bus driver told his passengers that they were going to take a little detour to see something that was not on the itinerary but was a "must see" in Detroit. The bus traveled east on Jefferson Avenue and turned north on Mt. Elliott to Heidelberg Street. My parents called me that evening and told me about an exciting and unique street art project they had seen that afternoon, a few miles from downtown Detroit. I knew immediately that they had seen the Heidelberg Project.

Two years later, when my mother asked me about the Heidelberg Project, I told her that the city had demolished part of it, similar to what it had done in 1991. She asked, "Why would they do that?" I responded, "It's politics."

Hundreds of articles have been published locally, nationally, and internationally about the Heidelberg Project. Guyton, Whitfield, and others have delivered dozens of lectures about the project. Numerous awards have been bestowed upon Guyton by local and state

governments, foundations, and citizens for his neighborhood revitalization efforts. Hundreds of schoolkids have worked on art projects with Guyton, both at the project and in their schools in Detroit and in other cities and countries.

Whether the Heidelberg Project, as we know it today, will be here for the next generation to experience will depend upon the foresight and depth of understanding of local politicians. One thing is certain: If the Heidelberg Project disappears, in the stealth of night or in the light of day, the world will be watching and asking why. ●

Marilyn L. Wheaton served as director of Detroit's Cultural Affairs Department for eight years. She was appointed director of the Marshall Fredericks Sculpture Museum at Saginaw Valley State University in October 2006. In addition to numerous articles, she wrote *The Detroit Artists Market, 1932–1982.* Wheaton is a longtime advocate for the arts who has consulted on issues of strategic planning, marketing, and organizational development.

Move to the Rear tagged with abandoned-vehicle notice, 1998. HEIDELBERG ARCHIVES.

DANIEL S. HOOPS

DEFENDING THE HEIDELBERG PROJECT

Dilapidated structures affixed with colorful and spiritual symbols condemned as unsafe. Vacant lots filled with painted ornaments and abandoned artifacts declared a trespass. An artist who has affixed polka dots to abandoned eyesores tagged a scofflaw. Thousands of visitors each year to an area known as Black Bottom deemed a nuisance by some residents. This is the Heidelberg Project.

On that day when Tyree Guyton and Grandpa Sam Mackey cleaned their paintbrushes on an abandoned house, no one could envision what they had embarked upon. No one, especially in the legal community, could have anticipated the highly unusual challenges that Mackey and Guyton's vision would spark.

From an attorney's perspective, the Heidelberg Project is a legal miasma that invokes strategies and concepts sometimes as thought provoking as the art itself.

Vast Legal Web

Almost every area of the law affects the Heidelberg Project, which is a nonprofit, tax-exempt, charitable foundation. The Heidelberg Project was organized with the State of Michigan as a nonprofit corporation in 1988. This status invokes principles under corporate law and tax law (including federal, state, and local tax issues). The Heidelberg Project is also the owner of real estate and artwork, thereby calling upon state rules of law governing real and personal property, environmental law, contracts, insurance, and torts. Statutes that protect individual artists and their creations also affect the Heidelberg Project on various levels.

This web of legalities begins with federal law, which governs all of the United States in a uniform manner. Each state then enacts its own set of guidelines, which apply to its residents; state laws that conflict with federal law are deemed invalid. Within a particular state's system of laws, each county and city has its own system of regulations and ordinances; these county and city rules must not violate the particular state's rules of law. In matters controversial, however, all these statutes often offer only a guide to the various combatants, as in the case of the Heidelberg Project

Federal Law — Federal law offers the strongest protection to the Heidelberg Project. The First and Fifth Amendments to the U.S. Constitution protect freedom of expression and

the rights of property owners. Considering that real estate and expression are the hallmarks of the Heidelberg Project, the Constitution is very much alive on Heidelberg Street.

The federal Copyright Act of 1978 shields copyright owners from the unauthorized exploitation of their creative works of art. This measure is especially important because of the Heidelberg Project's popularity among photographers. The Heidelberg Project must continuously monitor the Internet and various publications to prevent individuals from wrongfully profiting from photographs of Tyree Guyton's creations.

Finally, the federal Visual Artists Rights Act prohibits the destruction or demolition of certain outdoor works of art during the lifetime of their creator. This 1990 measure would appear to have been written just for Tyree Guyton, but Congress enacted this statute to protect muralists' works from desecration by property owners who purchased their holdings after the mural or work was installed on their building.

State Law — Michigan law governs the majority of the day-to-day issues that concern the Heidelberg Project. How its board of directors conducts business with third parties, how various contracts are interpreted, and the methods used to enforce the Heidelberg Project's contractual rights fall within the purview of state law. The most common of these daily concerns are real-estate title issues, insurance contracts, employees and volunteers, and various other corporate activities.

County and City Ordinances — Wayne County and the City of Detroit have enacted various ordinances that also apply to the Heidelberg Project and its operations. The majority of these relate to the Heidelberg Project's construction projects, which fall under specific building, zoning, and land-use regulations.

Ownership: Artist versus Foundation

The most important legal concept for the Heidelberg Project is ownership. Although this may appear to be simple, the elements at play with the Heidelberg Project make ownership a highly complex concept. On the one hand, there is the physical act of ownership and dominion over real and personal property, that is, real estate and works of art. On the other, there is the intangible ownership of intellectual property, that is, copyrights and moral rights.

Private Property–Public Display — The starting point with ownership is the Heidelberg Project's creator, Tyree Guyton. He is an artist. The Heidelberg Project is his studio. Heidelberg Street is his gallery. Most famously, the Heidelberg Project is a canvas that continues to evolve in Tyree Guyton's hands. Hence, the challenge: what Tyree Guyton, the artist, owns and what the Heidelberg Project, the charitable foundation, owns.

Detractors picketing during the 1997 festival. HEIDELBERG ARCHIVES. ▶

Heidelberg Project kids protesting pending demolition, 1998. HEIDELBERG ARCHIVES. ▶▶

When Guyton creates a piece of stand-alone art in his studio, he rightfully owns his creation. The physical work and the copyright belong to Tyree Guyton. While the physical work might be displayed on Heidelberg Street for all to see, it belongs to Tyree Guyton. He is free to sell the work, he may keep it, he may give the piece away (contrary to legal advice), or he may donate it to the Heidelberg Project. If he wanted to license a particular work for an advertisement, mass-produce a piece for sale, or publish photographs of it in a book, he would be entitled to do so as the copyright owner.

Work for Hire — When Guyton affixes a piece of art to one of the houses that the Heidelberg Project owns, in most instances this work (including the copyright) is a contribution by the artist to the Heidelberg Project. This theory is based on the artist's making a "work for hire" on behalf of the Heidelberg Project. The Heidelberg Project's board of directors therefore must approve of any display, licensing, or other disposition of those works that it owns.

Dual Ownership — Some situations can give rise to multiple ownership issues. The Heidelberg Project may own a particular work of art that Guyton has donated, but he continues to own the copyright. Therefore, if someone attempts to publish photographs of the Heidelberg Project, Guyton, as the copyright owner, could seek to prevent the reproduction of those photographs of his donated work, or he could sell duplicates of a donated piece without seeking permission from the board of directors.

Moral Ownership — The Visual Artists Rights Act confers upon artists the right to object to or prevent the "distortion, mutilation or modification" of an artistic work under the theory that it injures or damages the artist's honor and reputation. Although the Heidelberg Project owns the work and the copyright of any work for hire that Guyton creates for it, he still

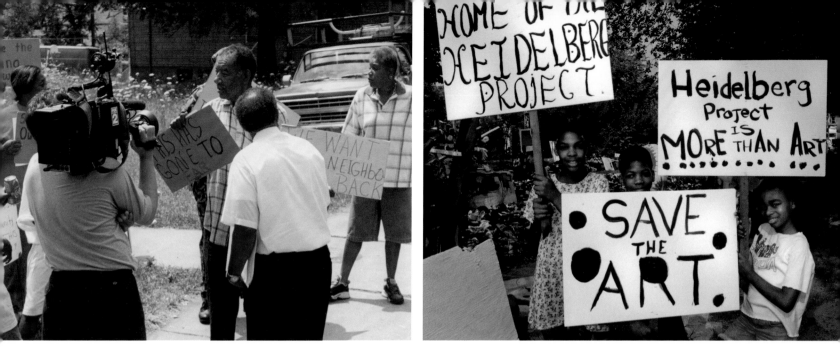

possesses the "moral rights" to this work under the Visual Artists Rights Act. What is interesting about this statute is that the artist cannot transfer these moral rights to any person, and these moral rights exist only during the lifetime of the artist. Therefore, once his work for hire is completed, the Heidelberg Project may not alter or destroy this contribution because he still possesses some intangible control of this work.

His moral rights can be of benefit to the Heidelberg Project in some situations. For example, if a house owned by the Heidelberg Project has been condemned as unsafe and ordered demolished, the foundation may not have any recourse to prevent the home's destruction if it is unable to comply with an order to repair the house. However, Guyton could draw upon his moral rights under the Visual Artists Rights Act to protect the artistic integrity of his creation. If he tried to stop the demolition of this house under this theory, such a move just might buy the Heidelberg Project additional time to comply with the repair order.

Who Is the Proper Party? — How to respond within the legal system when works of art are destroyed, stolen, or used in an unauthorized manner requires an analysis of who the injured party is and what type of action is warranted. Naturally, the process begins with Tyree Guyton, but is his status that of individual artist or contributing artist to the Heidelberg Project?

For example, if he is ticketed for painting a polka dot on a ramshackle building, is his action one of his own or an action on behalf of the Heidelberg Project? If he is acting on

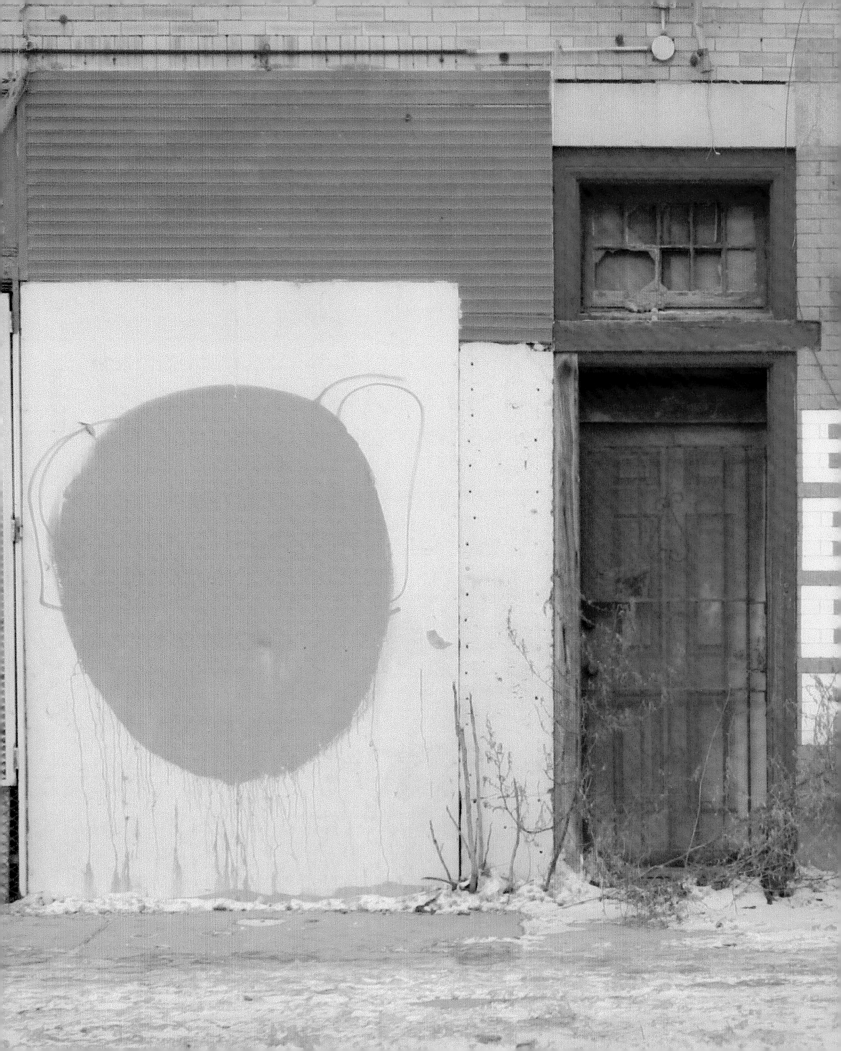

behalf of the Heidelberg Project, is the nonprofit at risk of criminal sanction? If a work that is part of the Heidelberg Project is tagged as an abandoned vehicle, should the Heidelberg Project pay the fine, or is the artist responsible?

If an item, such as a bus, is mysteriously removed from the project, who is responsible for filing the police complaint? Does the complaint cover the physical object *and* the intangible rights? What would the damage assessment be for an insurance claim? If an item is stolen, has the right to photograph and license the reproductions of those photographs also been stolen?

When unauthorized photographs of the Heidelberg Project are reproduced and sold, who is the rightful plaintiff in an infringement case?

For the most part, it is easiest to designate both the foundation and the artist as proper parties, then determine whether either should be eliminated from the particular action.

The Real Property — The houses and lots that make up the Heidelberg Project are actually one of the least difficult of the Heidelberg Project's legal questions. An economic reason dictates the ownership of the real estate on Heidelberg Street: taxation. Because the Heidelberg Project is a nonprofit entity, it is exempted from taxation. It may own an unlimited number of properties, free of real-estate tax, so long as those properties are used in the furtherance of its charitable purpose. For this reason alone the Heidelberg Project, and not Tyree Guyton, owns the majority of the real-estate used by the Heidelberg Project.

Public Property

The issues related to publicly owned property and the Heidelberg Project have always posed some interesting hurdles. The polka-dotted street and sidewalks, the animated trees, and uninhabited lots filled with smiling car hoods are all familiar features of the Heidelberg Project. They are warm, spiritual, welcoming, thought provoking, and creative symbols of the Heidelberg Project's purpose.

Rather than preserving, maintaining, and using the installations on public properties, local officials have scoffed at these expressions as mere destruction of public property. The irony, of course, is that the obvious intent of dressing public property is to harmlessly call attention to the various issues of blight, despair, and the forgotten.

Michigan Law — The law in Michigan is clear that the public roads, sidewalks, and easements on Heidelberg Street are the property of the City of Detroit, and whatever elements are affixed to those properties are subject to the control of the city. The Tenth Amendment to the U.S. Constitution confers this right upon the State of Michigan and its municipalities. Therefore, nothing under the First Amendment or the Visual Artists Rights Act can prevent a city contractor from eliminating the polka dots and faces painted on the streets and sidewalks.

One might argue that the First Amendment protects an artist's expressions on the streets and sidewalks. However, the freedom of expression is limited and will not cover creations made on another's property, absent, of course, the owner's permission. In other words, the First Amendment will protect Tyree Guyton's ability to produce polka dots generally, but he can be restricted from affixing polka dots to property owned by the city.

A lack of permission from the city to dress its streets and sidewalks would also defeat Guyton's ability to exercise his moral rights under the Visual Artists Rights Act. Most courts would not consider the polka dots or faces on the streets as works of "recognizable stature" that would give rise to sufficient moral rights.

Federal Law — Symbols, works, and other creative results that are simply displayed on city-owned lots do, however, enjoy protection from demolition and destruction under the Fifth Amendment to the U.S. Constitution. The Fifth Amendment, in conjunction with the First Amendment and the Visual Artists Rights Act, mandates that advance notice be given to the Heidelberg Project and Tyree Guyton before any public action is taken to remove, demolish, or otherwise seize artifacts merely displayed on city-owned lots. This notice could be in the form of a written letter addressed to the Heidelberg Project and Guyton, a police citation, or a notice posted on the particular piece sought for demolition or removal.

Demolition and the Civil Lawsuit

The Heidelberg Project has been the subject of a political tug-of-war since its inception. Various members of the Detroit city government have been accused of using Tyree Guyton and the Heidelberg Project as a pawn for their own political advantage. The number of civic

awards granted to Guyton and the Heidelberg Project are equal in number to the infractions issued by the same city government. Unfortunately, Guyton was the subject of two very difficult "tugs" by Mayors Coleman Young and Dennis Archer in 1991 and 1999, respectively; the result was the issuance of two orders for the demolition of the Heidelberg Project.

Demolition No. 1 — The 1991 demolition occurred under the Young administration with much publicity but limited recourse by the Heidelberg Project, attributable, in part, to its having very limited resources to mount the legal action necessary to counter the City of Detroit.

A few years after Coleman Young died, Guyton learned what the politics were behind the first demolition. The wide speculation at the time was that Young had personally ordered the demolition. However, an individual who was with Young that day has told Guyton that, in fact, Coleman Young did not issue the order—but someone in his administration did, in contravention of the mayor's political agenda. That put the mayor in a difficult position: if he rescinded the order, it would look like he had lost control of his administration, so he chose to proceed.

Wrecking crews tear down art installations, 1999. HEIDELBERG ARCHIVES.

Demolition No. 2 — For several years after the first demolition, Tyree Guyton and the City of Detroit seemed to be in harmony about the future direction for and acceptance of the Heidelberg Project. Transcripts of city council hearings, correspondence from Mayor Dennis Archer's office, and the physical resources of various city departments loaned to the Heidelberg Project seemed to be evidence of a true and honest partnership. Indeed, in the summer of 1998 Guyton and the city agreed that the Heidelberg Project would be moved to another location and the city would assist in the transfer.

Then, in late September 1998, Guyton was served with an order to dismantle the Heidelberg Project or the City of Detroit would demolish it. It is believed that this order was prompted by a few vocal community activists who opposed the Heidelberg Project and the attention it garnered. On September 22 Guyton sought and received a temporary restraining order from the Wayne County Circuit Court that halted the demolition of any part of the Heidelberg Project. This order was in effect until February 4, 1999, when the court lifted it (the judge who had granted it originally had lost her reelection bid). Within two hours of this decision, nine police cars, a police helicopter, and several demolition vehicles arrived on

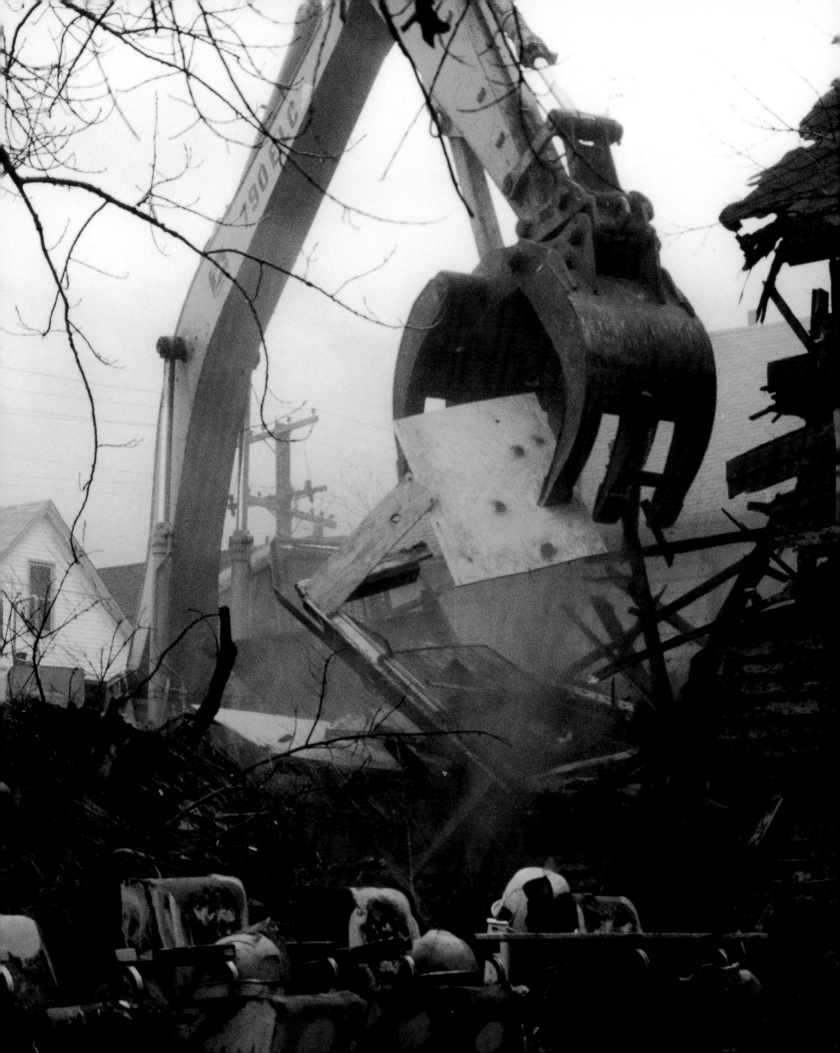

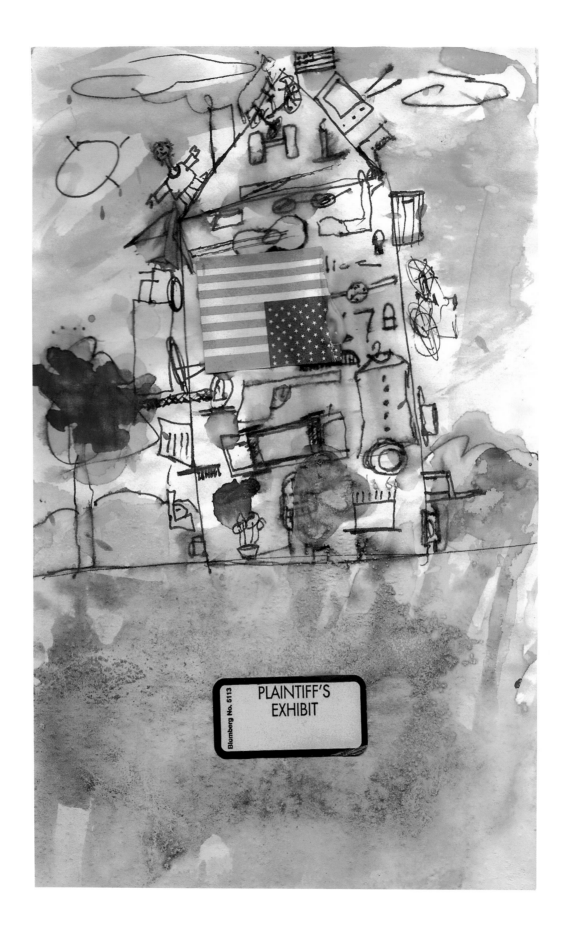

PLAINTIFF'S
EXHIBIT

Blumberg No. 5113

Heidelberg Street and commenced to decimate the Heidelberg Project. The demolition included the complete destruction of two privately owned houses. The following day, without any advance notice, the city also demolished Guyton's studio, which was only blocks away. In the course of two days the city destroyed 40 percent of the Heidelberg Project.

Rather than buckle to the disingenuous and malicious actions of the City of Detroit, Guyton sought and assembled a legal defense team that went on the offensive. His lawyers filed a massive complaint with the Wayne County Circuit Court that sought, among several things, damages from the City of Detroit for its callous and retaliatory destruction of his artwork. Numerous expert witnesses were called to appraise the value of the Heidelberg Project and the works in Guyton's private studio, Detroit city officials were called as witnesses, and hundreds of exhibits were submitted for evaluation in a jury trial. Although the Wayne County Case Evaluation Panel assessed the range of damages for Guyton at $500,000 to $30 million against the City of Detroit, the jury returned a verdict of "no cause" in favor of Guyton but awarded no damages.

While this verdict might have been characterized as a major setback, Guyton found the fortitude to look past it and publicly declare that he would rebuild. More important, he made it crystal clear to the world that he would not be bullied or caught off-guard by the hollow promises made by politicians.

Ironically, the 1999 civil lawsuit actually enhanced the Heidelberg Project's legal standing. During the legal proceedings the Wayne County Circuit Court determined that Tyree Guyton's artwork is "political speech" and that the display of his artwork is a protected activity that is not subject to the city's regulation if it is displayed on private property. Because the city's lawyers did not appeal part of the decision, Detroit is forever prevented from destroying any part of the Heidelberg Project displayed on private property within the city limits.

Untitled Study, 5 x 8 in., 1993, as exhibit in lawsuit against the City of Detroit, 1999. HEIDELBERG ARCHIVES.

The sheer volume of transcripts, exhibits, and legal memoranda generated by this civil lawsuit is mesmerizing. At one point the city had five of its senior lawyers assigned to the suit. But the thorough preparation of the Heidelberg Project's legal team for the trial, especially in regard to constitutional protections, including the protections against the "taking" (or

demolition) of property without due process of law, has made Detroit quite cautious about taking legal action against Tyree Guyton and the Heidelberg Project.

Acquisition of Properties

An ongoing frustration of the Heidelberg Project has been the difficulty of acquiring real estate on and adjacent to Heidelberg Street. Local government actually owns several parcels identified by the project's board of directors as important or necessary for the preservation of the Heidelberg Project. The city has acquired ownership through a variety of means, including seizure under tax foreclosure or other nuisance actions. Although the Heidelberg board has made several attempts to buy these city-owned lots and structures, it has not succeeded.

Since the Heidelberg Project has always been a willing buyer without a willing seller, it has been forced to follow some interesting paths to property ownership.

Public Auctions — The two-story residence known as the House of Words was actually purchased from the Wayne County Prosecutor's Office by a private supporter of the Heidelberg Project after the property was seized under criminal forfeiture laws. The occupants of this house were charged with buying, selling, and using illicit drugs within the house, thereby subjecting the residence to criminal forfeiture. Upon formally taking title to this house, the prosecutor's office posted it for public sale on the Internet. The listing came to the attention of Jenenne Whitfield, the project's executive director, who immediately enlisted a supporter who then outbid several challengers. Shortly after the auction the Heidelberg Project purchased the house from this supporter. But that was not the end of it. After the Heidelberg Project leased this house to a public relations firm, the City of Detroit flagged the House of Words as uninhabitable and set a date for its demolition.

The Heidelberg Project also acquired properties from Wayne County through its annual tax sale. In these instances individual property owners failed to pay their city and county real-estate taxes for two consecutive years and forfeited their land to the county. The Heidelberg Project has participated in the Wayne County treasurer's public auction and has purchased several important lots through this method. For instance, the vacant lot that serves as the Heidelberg Project's welcome center was purchased at the treasurer's auction in 2004.

Charitable Donations — An underused technique available to the Heidelberg Project for acquiring property is its exemption from taxation under Section 501(c)(3) of the Internal Revenue Code. This section allows individuals and businesses to donate property to the Heidelberg Project and to receive, in return, a charitable deduction from federal tax on their income or estate tax returns.

Although the Heidelberg Project has identified the owners of all the houses and lots on Heidelberg Street and the neighboring streets, most owners are not in a financial position to donate their property in exchange for a charitable deduction. Furthermore, the Heidelberg Project has never sought to purchase or acquire real property from those individuals who actually reside in the neighborhood. Nevertheless, the Heidelberg Project remains amenable to accepting donations of real property from willing donors.

Since its inception the Heidelberg Project has garnered worldwide recognition, yet locally it has had to suffer the results of civic scorn, including demolition, threats of criminal prosecution, and theft. Its lawyers have devised unique strategies over the years to deal with the project's local opponents and to protect this Detroit treasure while also furthering the mission of the Heidelberg Project's creators. It is fair to say that the creativity of the Heidelberg Project has infected the attorneys and the legal strategies they have devised. ●

Daniel S. Hoops is a legal and business consultant to artists, musicians, and nonprofit institutions. He has been a Heidelberg Project board member since 2003.

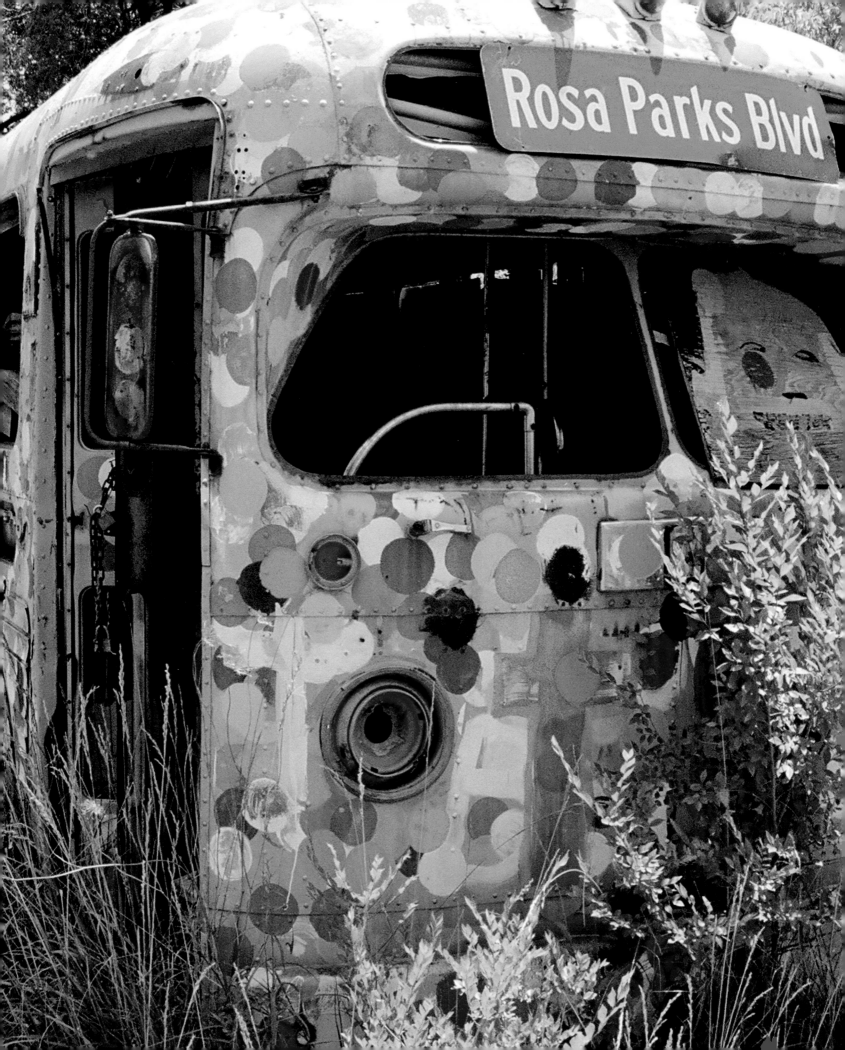

HEIDELBERG
ART AND ABOUT

AKU KADOGO

◀ *Move to the Rear*, 2005. JACK JOHNSON.

On a summer's eve in 1996 when I was back in Detroit for a visit, my parents took me for a ride to the East Side, and we turned down Heidelberg Street.

Boom!

An explosion had taken place there. Dolls' heads, myriad televisions, countless "faces of God," American flags, vacuum cleaners, shoes, shoes, shoes, and more shoes! A bus painted with polka dots, a house with numbers on it, another with hubcaps and dots, a house with posters and "OJ, OJ, OJ" painted all over it. In the midst of this inner-city blight was a fantasyland of twentieth-century detritus.

What I saw on Heidelberg Street was beautiful, chaotic order. What I discovered was that a citizen of the world had taken matters into his own hands to induce dialogue, to make people shout with joy or anger, to dare to *think*. Welcome to the world of Tyree Guyton!

Guyton dared to shake us out of malaise and mobilize us into discussions with our neighbors, our city council representatives, our mayor, folks who don't live next door, young folk, poor folk, rich folk, homeless folk, folks who speak other languages. We all found ourselves on Heidelberg Street, cajoled, annoyed, grateful, awed, and yet moved to do anything but just stand there. This is the power of art.

Stupefied by the messages we were getting, we were amazed that one man had one day walked out his door and declared that he was no longer going to be complacent about what was happening to his city. Art is a righteous weapon for firing us up and creating havoc with our sensibilities, forcing us to use our *imagination*. What a concept.

All I could think of, after that moment of introduction to his art, was that I wanted to meet the man who had created this "sacred site." I have been living in Australia since 1978, and I work in the indigenous community there. My journey has allowed me to be in the presence of medicine men and women, and I understood Tyree Guyton's work to be that of someone who holds sacred knowledge for his community. The medicine man has to dole out a bittersweet pill. So here was a medicine site for Detroit. Whether one liked it or not, the controversy created by the Heidelberg Project forced Detroiters to take sides. Heidelberg Street brought us together to debate, to take action. Imagine what would happen if we also began to debate the economic situation in which we find ourselves. Imagine what would happen if we taught

our young people to create their own fates and to use their imaginations. The art installed on Heidelberg Street is a start.

It took me four years to meet Tyree Guyton. On one of my trips to town my friend the late Ron Milner asked whether there was anyone here whom I'd like to meet. "There is only one person I'd like to meet, and that is Tyree Guyton," I replied. One cold, wintry Christmas night, Ron made a phone call, requesting an audience with Guyton and Jenenne Whitfield, the executive director of the Heidelberg Project. We met two days later, and the first words I uttered were, "Hi, would you like to come to Sydney, Australia?" I had hardly intended to say those words, but they spilled forth as though someone else had preordained an event about which I knew nothing, although I would become its unrelenting champion until the project was completed.

I became determined to work with Guyton as soon as I laid eyes on the Heidelberg Project back in 1996. I realized that his work represented cultural knowledge that went beyond cliché. His work represents facets of African American wisdom that are universal and deserve to be shared internationally as we grapple with the rapidly changing, chaotic times in which we live.

My manager, Marguerite Pepper, and I invited Guyton to come to Sydney to create Singing for That Country, a project inspired by his dots, his shoes, his faces, and his ability to "get inside the people." We worked with the indigenous, the young, the non-English speaking, city council members, youth workers, university students, and artists. We created a large-scale outdoor performance installation for the City of Sydney's Art and About Festival, an annual visual arts festival that takes place in the spring. For three weeks the works of emerging and established Australian artists, along with international artists, are displayed on the streets and in open spaces, public spaces, and galleries. We mounted Singing for That Country in the festival's third year.

Guyton made three trips to Australia in 2004. My intention was to introduce him to an outdoor environment that had undergone a number of transformations during the previous 150 years. Sydney Park had been natural bushland when it became the site of a factory kiln for ceramic bricks at the turn of the twentieth century. Eventually, it became a rubbish dump

that was reclaimed in the 1980s and, more recently, had been turned into parkland featuring native flora. Despite the property's history as a dump site, urban Sydney offered an experience that was the antithesis of Detroit. Indeed, at one point Guyton complained that he could find no junk on the streets. Instead, he marveled at the city's variety of bird life.

I spent several months working at five youth sites, painting shoes and tires that would become ingredients for our installation. In September 2004 Guyton returned with a group from Detroit that included Jason Lee and Erika Batchelor, two young Detroit-area residents who had never been abroad. This visit was to become a cross-cultural exchange of art and information. I was mentoring a young indigenous woman, Tatea Riley, who served as my assistant and indigenous protocol host for our out-of-town visitors. Their duties included painting, installing, and making recordings for the sound installation.

WE ALL FOUND OURSELVES ON HEIDE GRATEFUL, AWED, AND YET MOVED TO

There were three designated sites: the South Sydney Youth Services skateboard park, Sydney Park, and the Redfern Community Centre. Ambitiously, we began with the skateboard park, mounting colorful tires and painting huge polka dots. The skateboard park is a haven for young men who have embraced skateboarding rather than the illegal activities that attract some of their peers. The park is located in a transitional area; affluent residents have been eyeing the neighborhood, and their interest threatens to displace longtime residents. The bright alternative that was offered by our installation created havoc for the young men who skated there. We returned one Sunday afternoon to put the finishing touches on the artwork, only to discover an eleven-year-old skateboarder with wire cutters who was severing the tires and rolling them downhill into oncoming traffic.

Needless to say, we were disappointed. This reaction to art was the first of several tribulations. Tyree Guyton, the medicine man, had struck once again and was doing battle far from home.

In the primary site, Sydney Park, we installed large dots, dressed the trees with frocks dancing in the breeze, put shoes with handwritten notes inside, and encircled the site with

large canvases that Guyton had painted, along with some done by students from Alexandria Park Community School. The painted tires became the welcoming "totems" for the installation. On the weekend that we unveiled the art, there were performances by young people, a short film produced by three university students who had documented the creative process, and two spoken-word artists. Nudged by the dots, shoes, faces, and detritus I had seen on Heidelberg Street, this was my attempt to bring disparate groups of young people together to create.

All along I had assured Guyton not to worry about rain because Sydney had experienced drought conditions for the past three years. But you know Murphy's Law: If something can go wrong, it will, and in the final week the rain came. Because buckets fell from the sky for days on end, the third installation, at the Redfern Community Centre, never came about.

ERG STREET. CAJOLED, ANNOYED, DO ANYTHING BUT JUST STAND THERE.

Again, I was disappointed, as this community center is located in a long-standing indigenous stronghold that is under threat from gentrification.

However, what emerged, for me, is an ongoing, dynamic working relationship with Tyree Guyton and the Heidelberg Project's board. Singing for That Country was a pilot effort to merge performance with his art, which is already theatrical on its own. Today, Guyton's message stands atop a panoramic view in the middle of Sydney town. His art remains strong and intact, affecting all who encounter it, for better or worse. ●

Aku Kadogo is currently director of the Black Theatre Program at Wayne State University, a choreographer, and a performance artist. She created Singing for That Country in collaboration with Tyree Guyton for the Sydney Art and About Festival, 2004. She was the director during the summer of 2006 for the Heidelberg Project's twentieth anniversary celebration, the Connect the Dots festival. Her ongoing work with Guyton and the project thrives. She lives in Sydney and Detroit.

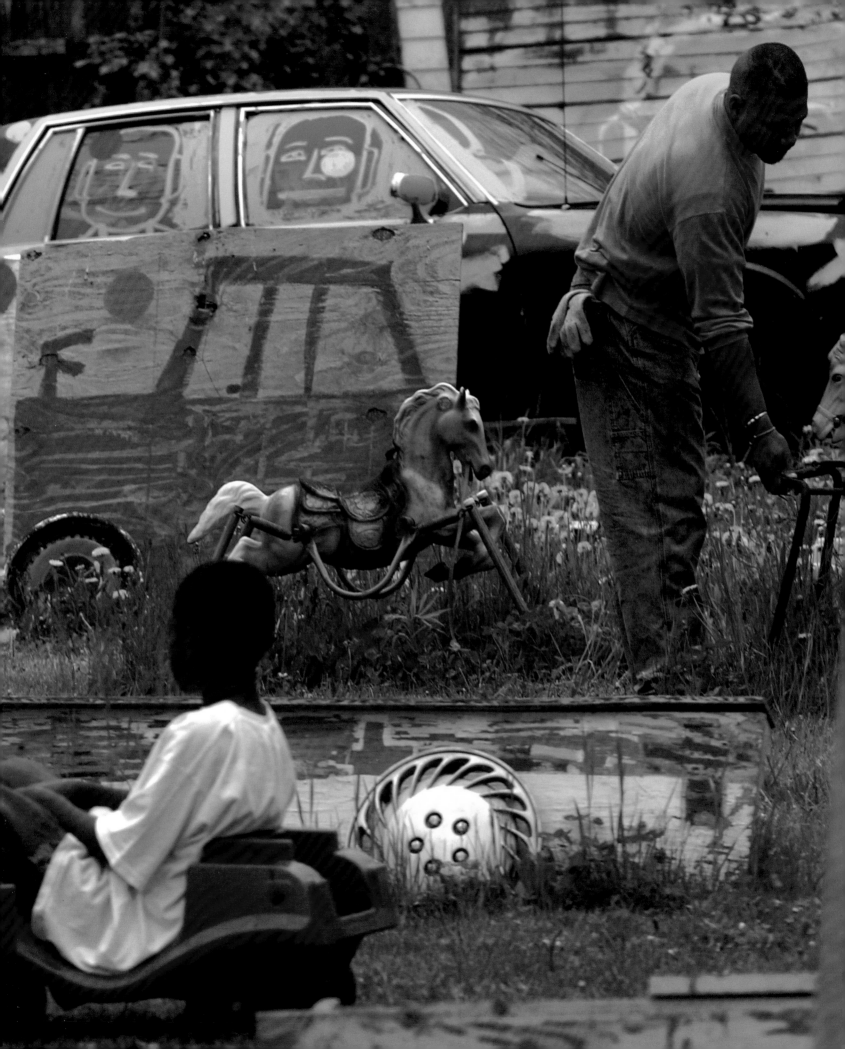

AN INSIDE VIEW

JENENNE WHITFIELD

◀ Neighborhood child relaxing in one of Guyton's installations, 2003. DONNA TEREK.

When Tyree Guyton started the Heidelberg Project twenty years ago, he had no idea that it would evolve into the critically acclaimed and provocative work of today.

According to Guyton, the Heidelberg Project was born of his own experiences and hardships while growing up in a community that experienced devastating changes. What once was a diverse working-class neighborhood became a community characterized by violence, racism, abandonment, despair, and poverty.

Many have pondered what the Heidelberg Project really is. From a simple inside perspective, Guyton's work is an outdoor art environment/artscape in the heart of an urban community on Detroit's East Side. It is fashioned from everyday refuse such as car parts, stuffed animals, shoes, and other items painted and woven into the landscape of Heidelberg Street.

The first-time visitor may find the Heidelberg Project foolish, trite, whimsical, childlike, even junky. One might wonder what was on the mind of the person who devised such a . . . thing. *I certainly did*. Some who actually live within the project feel embarrassed or insulted by Guyton's creativity and say that his work attracts outsiders who gawk at already embarrassing conditions, while others within the community celebrate and protect Guyton's large landscape.

Artists and those bitten by the infectious bug of creativity but who live outside the community feel a kinship and immediately want to be part of it. Yet another audience is the academy, whose denizens feel compelled to define, compare, evaluate, and analyze Guyton's work.

But what, exactly, is it? Honestly, I don't know—I say, let the experts decide! What I do know, however, is that the way in which we attempt to understand, define, or explain the Heidelberg Project will almost always be based on our own worldview. And that's okay—after all, it's human nature to compare new information with the stuff we already know. On the other hand, if you open your mind and take a close look, you'll find, lurking behind the myriad junk-turned-art-objects, something very powerful, mysterious, confronting, something . . . well, *extraordinary*.

Spending time on Heidelberg Street is an amazing experience. Indeed, the calm and intrigue of a colorful street in the midst of utter chaos and blight is something to behold.

Imagine a beautiful sunny spring afternoon. Flocks of cars are cruising leisurely down the street. People are pointing their fingers while they stare in amazement. Children are playful and delighted at the array of objects brightly colored and systematically arranged.

Imagine an elderly white couple parking their vehicle and getting out to take a casual stroll down a polka-dotted street in the heart of an urban ghetto. They show absolutely no signs of trepidation but instead inquire with poise and confidence about the man who created the work. Imagine a homeless man who finds refuge under an old camper-turned-art-piece who is inspired in the morning to play his guitar for visitors. Imagine a group of international exchange students who spread a blanket on one of the vacant lots and picnic. Imagine police officers escorting a group of lost tourists to the site and then returning on their own time with their own visitors. Finally, imagine if you will a four-year-old neighborhood child who is saying hello in French after spending time with visitors from Paris.

All this and more takes place on Heidelberg Street on any given day. It is a magical place, visited by some of the most interesting people from around the world.

A sign that once stood at the corner of Heidelberg and Mt. Elliott streets read, "The Heidelberg Project is Saying, Seeing and Feeling all things. My humble opinion is that the Heidelberg Project cannot be squeezed into a single definition. It is, in fact, many things to many people. When you experience it personally, it defines itself to you, whether negatively, positively, or indifferently. It simply does not conform to the traditional or systematic sense of what art—or a community, for that matter—should be. That's what makes it exciting—provocative—conversational—and in a class all by itself. It is, in effect, the complexity of the Heidelberg Project that makes it so extraordinary. *Conanlsren*

Does the Heidelberg Project address only the brokenness and despair of a community? Absolutely not. It also speaks messages of humor, joy, and life. Sometimes people think that when you live surrounded by poverty and desolation, you can have no happiness and appreciation for life. Ironically, and perhaps consequently, the harshest conditions can give birth to profound creative energy and a greater appreciation for the simple things.

In this way the Heidelberg Project becomes our teacher. It provides a platform for discussions on various levels with people from all walks of life. It challenges our beliefs about

art, life, people, society, community, economics, class, and religion—just about any subject dealing with humanity. It reminds me of a passage in the Bible, 1 Corinthians 27: "But God hath chosen the foolish things of the world to confound the wise; and God hath chosen the weak things of the world to confound the things which are mighty."

Indeed, the Heidelberg Project confounds the so-called leaders of today. Detroit's politicians and others still are not sure what to make of the Heidelberg Project. In the past, when they didn't know, they

Shooting *Come unto Me: The Faces of Tyree Guyton,* 1995. HEIDELBERG ARCHIVES.

destroyed—twice. Certainly, the Heidelberg Project appears to be foolish and vulnerable. And the objects that Tyree Guyton chose to use to create his work are indeed weak, despised, and rejected. Each time the project was destroyed, the man and the work came back stronger and more determined. Today the Heidelberg Project stands stronger than ever.

Has the Heidelberg Project challenged our thinking about wreckage, rubble, and other seemingly insignificant materials? I would say so. Guyton's use of found and discarded materials and objects has forced many of us to also see how we often discard communities and people. The symbolism in Guyton's works is so compelling and gripping that many folks vehemently oppose Guyton's work and the man as well. Nevertheless, the Heidelberg Project has provided a voice for the suffering and demoralized.

Personal Testimony

While it is refreshing and stimulating to express the philosophical aspects of the Heidelberg Project, and how it means many things to many people, many people wonder how it functions. What is its day-to-day operation? How is it funded? What is its structural makeup? This is where the Heidelberg Project becomes very tricky.

As an organization, we are continually challenged as we attempt to shift the Heidelberg Project to its next stage. Our internal process moves at a snail's pace, as if to compel us to look deeper and fully open our minds to a new way of operating.

From this point I must digress and share a bit of my personal history. I was born and raised in Detroit on the West Side of the city. If you know anything about Detroit, you know

about the long-standing division between the East and West sides—each claiming superiority over the other.

Was I a victim of this mode of thinking? You betcha. I bought both this internal form of classism and the unspoken dictum against traveling to the East Side of Detroit. And believe me, many "East Siders" feel the same way about the West Side, even today.

In June 1993, I ventured off the beaten path of my regular route to work and grudgingly entered the East Side of Detroit, thus stumbling into the world of Tyree Guyton. Asking one simple question—What in the hell is all of this?—would forever change my life.

I had no knowledge of and no interest in the likes of Tyree Guyton and his cause. I was a career woman climbing the corporate ladder in banking and finance. I was in sales, making $70,000 a year, had fourteen years of seniority, stock options, a 401k, a new house, and a beautiful four-year-old daughter. And even though I felt that something essential was missing from my life, the last thing I wanted to hear about was some fanatical man with the crazy notion of saving the world with junk—starting on the *East* Side of Detroit.

During our first encounter, Tyree Guyton was standing in the midst of his junk-turned-art when he politely took out a pen and asked me to sign his guest book. I remember thinking, "A *guest book*? He can't be serious!"

During our conversation Guyton never once talked about himself, his vision, his cause, or his work. Instead, he questioned me and asked what my life was like and how was I using my talent to contribute to society. When I told him about my work, his reply was, "So you help other people make money." Something about the way he said "other people" bugged me. As smart as I (thought I) was, I was dumbfounded, a bit insulted, and in no state of mind to go to work. I told Guyton that I had to get going. As I turned to leave, he took out a postcard of one of his creations (the Baby Doll House), signed it, and asked if I could come back the next

THE HARSHEST CONDIT
PROFOUND CREATIVE
APPRECIATION FOR THE

day—he wanted to show me something. I told him that I would try and thought to myself, "Maybe I can help him get a grip on the real world."

I returned the next day, which was a Saturday, hoping to learn more about Guyton's mission and why he had gone to such an extreme. The day started with Guyton's intentionally shocking me by acquainting me with new people and places. One was a homeless man whom Guyton introduced as his friend Printess (Guyton was deliberately taking me to a very different place).

I met other people on Heidelberg Street that day, but I was most intrigued by a handful of children who flocked around Guyton, competing for his attention. These kids had magic in their eyes as they talked, pulled, and tugged at Guyton. Finally, he walked me around his art place, but, again, he didn't go into detail about himself or his art. Instead, I spent time in a place where my fears sometimes surfaced but at the same time I was wildly intrigued.

Over the next three months my visits became more frequent, and I began to bring

friends, family, and other West Siders. No one really knew what to make of Guyton's work, but I had fun shocking them just the same. When friends would ask me what the Heidelberg Project was, I told them that Tyree Guyton was an artist and that the Heidelberg Project was an experience. The truth is that I just didn't know what else to say. Some found it amusing, others hated it.

Eventually, Guyton asked me if I could help him. I told him no, because I didn't know what he was doing. He began showing me correspondence from all over the world. People were writing to him from Germany, Russia, and France and from all over the United States to say how much his work inspired them. Some wrote about their visit and how much they enjoyed meeting Guyton, his grandfather, and Karen, to whom he was then married. They

ONS CAN GIVE BIRTH TO ENERGY AND A GREATER SIMPLE THINGS.

wrote about Guyton's courage and determination. Some encouraged him not to give up and others expressed an interest in helping. However, one particular letter that Guyton shared with me really blew me away. It was an invitation from Oprah Winfrey to appear on her show again. I asked Guyton who was responding to all these letters. "No one," he said.

That is where I began my journey. I blew the dust off my computer and began to respond to all those letters. I was completely lost and out of my realm. I knew absolutely nothing about art, nonprofits, 501(c)(3)'s, or philanthropic work. I didn't even know what Guyton was doing, so I did what most professionals do in corporate America: I gave polite yet vague responses (later I would learn just how well that didn't work). If I was to continue volunteering my time to Guyton's cause, I had to learn more about him and his work.

What I learned about the man, his art, his vision, and his life was so amazing that I began taping our conversations. I learned about Guyton's family life and his passion for art, which was inspired by his grandfather. I learned about his children, his failing marriage, and

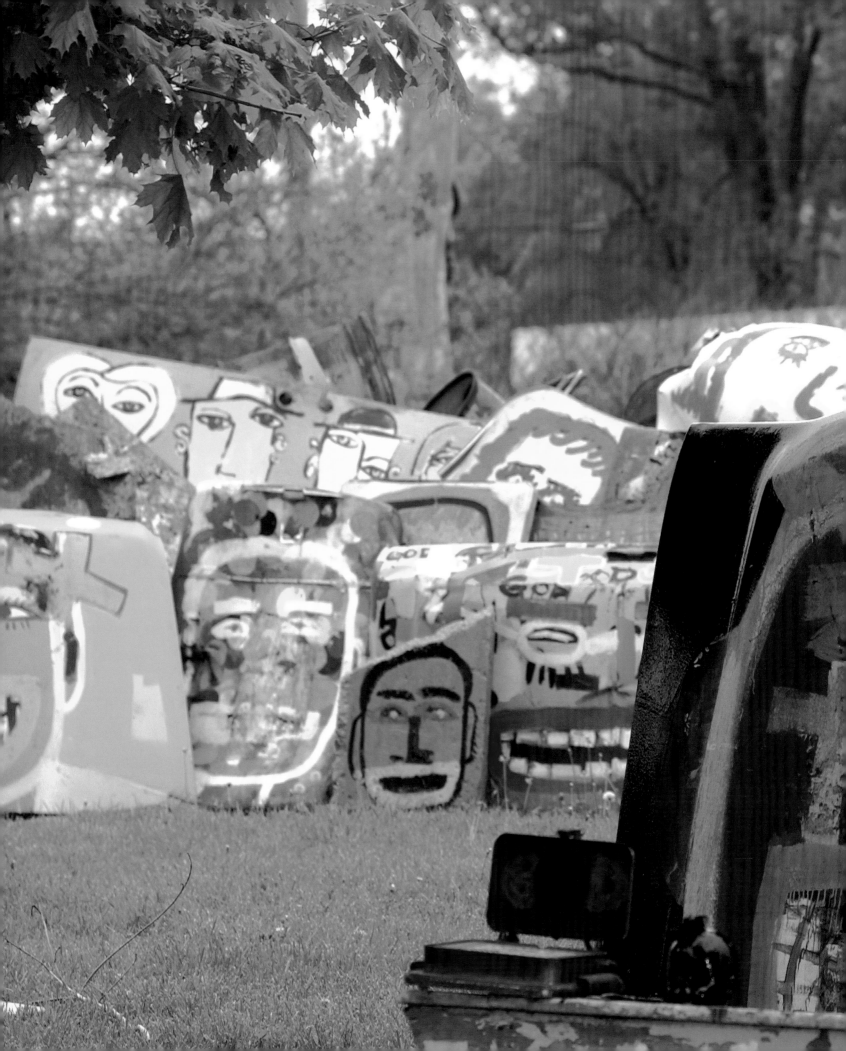

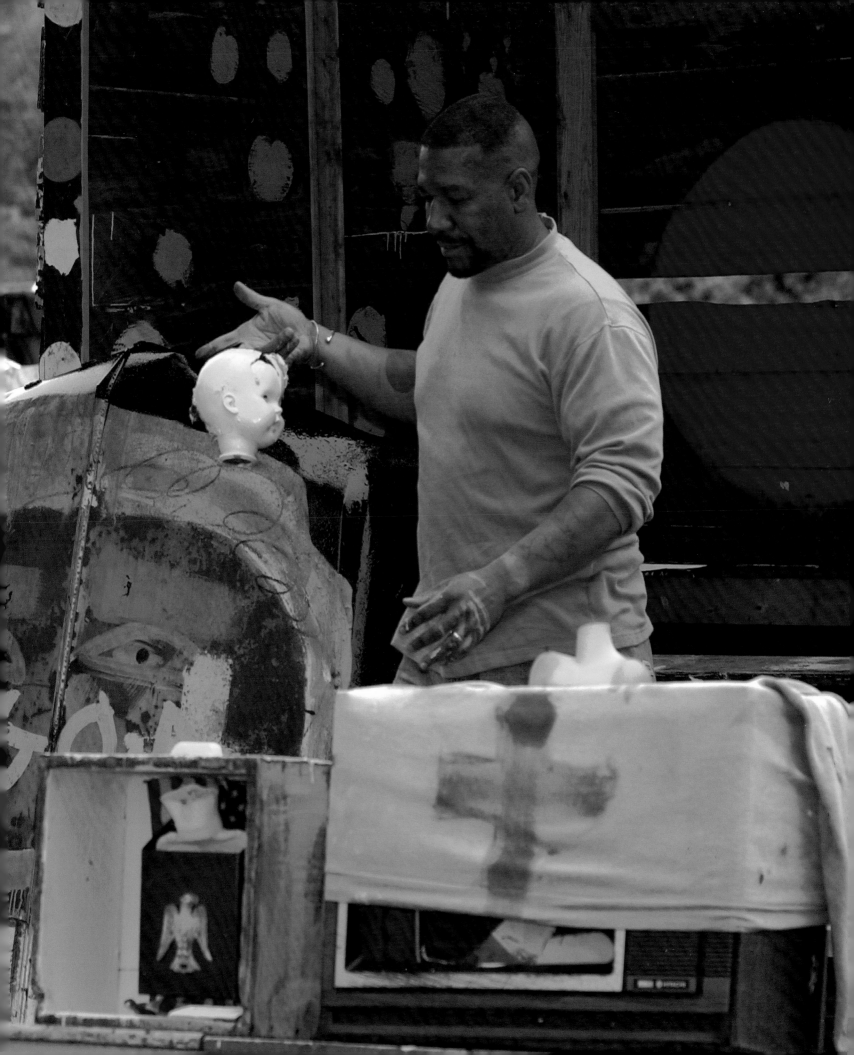

three brothers who had died on the streets. I learned about the demolition of his work in 1991 and how he had vowed to continue. Guyton also helped me to discover beauty in the simple things of life.

Guyton was brilliant and at the same time troubled, compassionate yet hotheaded, unorganized and steadfastly focused. Our meetings became almost ritualistic and to some extent therapeutic for Guyton and for me. At that time I had been studying metaphysics for about twelve years, and I began to see how my life's work was about to change, which scared me.

Because of my background in business and finance, organizing my work for Guyton was not difficult. I began reading and researching everything I could find about Guyton and his art. He brought me mounds of paperwork that I read and organized. I could see that Guyton had indeed done something incredible, yet I still wasn't sure exactly what he was doing.

I needed help. I began contacting some of Guyton's friends who had helped him establish his work on Heidelberg Street as a nonprofit with a board of directors back in 1988. One of those friends and longtime supporters of Guyton, Tom Porter, informed me that no one was sure what Guyton wanted to do after the demolition of 1991. There was a breakdown and a great deal of turbulence during that time; consequently, the board ceased to function. Although I didn't know it at the time, Tom cared deeply about Guyton and was initially hesitant about my sudden and aggressive interest. Nevertheless, he supported me every step of the way. I wrote letters, made phone calls, and began to learn whatever I could about the nonprofit sector. In April 1994 we held a meeting attended by approximately twenty of Guyton's friends and supporters. Guyton told them he was ready to begin rebuilding the Heidelberg Project and that he wanted to take it to the next step. They all agreed to do what they could to help.

Function and Operation

Two months later I quit my job and became the executive director of the Heidelberg Project. I had no salary, no definite plan, and not much support from my friends and family. They didn't understand, and neither did I, but I was captivated by what I had learned and I knew that Tyree Guyton was on to something.

The Heidelberg Project eventually began to function like a business. Guyton remained in charge of the structure of the Heidelberg Project, and I took on fiscal management and administration. I transformed my basement into an office, and we were in business. I began building relationships with business and political leaders throughout the city and the state and slowly reestablished a board of directors consisting of both old and new participants. I began attending seminars and workshops on the operation of nonprofits. I developed site tours and programs for children and adopted the neighborhood elementary school that Guyton had attended. With the help of volunteers and the board, we began applying for grants and generated tremendous interest from schools and universities around the country. That led to lectures and exhibitions throughout the United States and in other countries. Meanwhile, Guyton was rebuilding and expanding the Heidelberg Project. Along the way that first year, he picked up three awards to add to his already growing collection.

By 1995, with the help of students from various universities, we had developed a site plan for the Heidelberg Project that proposed an artistic cultural village. The plan called for the renovation of several houses within a two-block radius into funky art structures, meditation gardens, sculpture gardens, and more. We believed that the Heidelberg Project could jump-start economic development in the community. It was also at this time that our work became the subject of a documentary.

Guyton's work was reaching an even broader audience than previously. Someone from virtually every walk of life had read about, heard about, or experienced the Heidelberg Project. Guest book records revealed that residents of every state in the United States and more than ninety-eight countries had visited the Heidelberg Project. Additionally, statistics compiled by one of the project's attorneys, Gregory Siwak, showed that in 1998 the Heidelberg Project was the third-most-visited tourist attraction in the city (behind the Charles H. Wright Museum of African American History and the Detroit Institute of Arts), yet our audience was more diverse than both our competitors'.

By the spring of 1997 the Heidelberg Project was rising to the challenge of becoming a functioning art community. We had developed programs within the community, including adopting Ralph J. Bunche Elementary School and establishing an ongoing artist-in-

residence program. On Saturdays during the spring and summer, we held art programs on-site for neighborhood children, who participated in a variety of art experiences, including painting, poetry, music, and dance. Children were also trained as docents and eagerly greeted visitors while showing off areas of the project they helped Guyton create. On at least three occasions, children participated in programs on Heidelberg Street with the Children's International Summer Village, an exchange program made up of children from all over the world.

One of our greatest contributions, in my opinion, has been employing people in the community. Many of the people Guyton hires to clean up and maintain the project indulge in behavior that would prevent their receiving employment elsewhere. Guyton understands their plight, having three deceased brothers who experienced much of the same. This cooperation forms a dual purpose: it offers a disconsolate, often desperate, class of people employment opportunities, and this in turn helps to decrease the occurrence of petty crimes in the community. Today, these workers are the police of the Heidelberg Project.

In September 1997 we were confronted with political opposition that included the neighborhood citizens' district council (CDC). For the next year the Heidelberg Project was preoccupied with citations, tickets, meetings with the Detroit City Council, and picket lines. Throughout most of 1998 we met with the city council and the McDougall-Hunt CDC, both of which were fervently opposed to the Heidelberg Project. The McDougall-Hunt CDC was primarily made up of nine people, mostly senior citizens, who claimed to be the voice of the community. They dogmatically maintained that the people of the community did not want the Heidelberg Project, that it was an eyesore and would reduce property values. We thought that just the opposite was true. The mere Face prompts exploration of religion and war, 2005. JENNIFER BAROSS. ▸ fact of the Heidelberg Project's continuing existence in a community where houses were being burned and abandoned almost daily spoke volumes about community support. And according to the State Equalized Value Property Assessment from 1996 to 2000, the value of at least three houses on Heidelberg Street had consistently increased by an average of 14 percent.

Nevertheless, during this time the public image of the Heidelberg Project began to suffer, and it became characterized as contentious. Many Detroiters began to take sides.

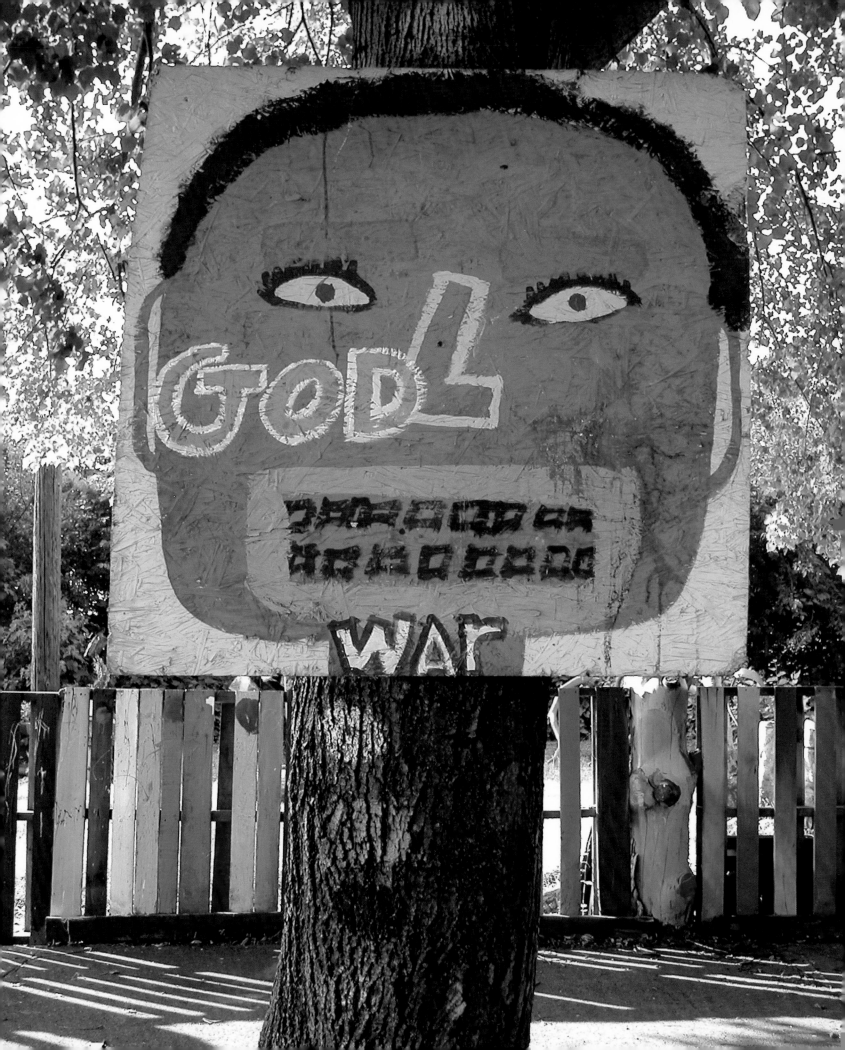

Newspapers and television crews eagerly covered developments in the battle between the Heidelberg Project and the McDougall-Hunt CDC. To some degree the African American community and the media coverage pegged the Heidelberg Project as an enormous organization supported by suburbanites that was stepping on the poor residents of the community. By contrast, national and international news stories poked fun at a city government that failed to embrace what had become an international art treasure. Any hopes we had for local funding and support were now long gone; the Heidelberg Project was a political hot potato. We watched helplessly as the racial divide in our city began to widen, exactly opposite of the effect that we had intended.

Late in the summer of 1998, the Detroit City Council, supported by then-mayor Dennis A. Archer, ordered the demolition of the Heidelberg Project. However, we sought and won a restraining order that September from Judge Claudia A. Morcom. Unfortunately, she was not reelected to the bench, and in February 1999 we experienced the second (partial) demolition of the Heidelberg Project.

This time I was there. This time I felt the pain and saw with my own eyes how the city destroyed years of not only Guyton's work but my work as well. Nothing could have prepared me for the emotional roller coaster we would soon be riding, for even as we were experiencing the pain and humiliation wrought by the city's actions, great things were happening for the Heidelberg Project in other parts of the country and the world.

That year we learned that a documentary, begun in 1995 and produced by Naked Eye Productions, had been licensed for one year to HBO/Cinemax's *Reel Life Series*. We traveled to New York for the television premiere of *Come unto Me: The Faces of Tyree Guyton* and later that year to the Sundance Film Festival for yet another screening and an Honorable Mention award. In 2000 the film received an Emmy Award. Also that year we were invited to the Harvard School of Art and Architecture to create an outdoor installation in celebration of the school's one hundredth anniversary. I should note that some of that work once adorned Heidelberg Street, where the City of Detroit deemed it an eyesore. Also in 2000 the U.S. ambassador to Ecuador invited us to Quito to represent the United States in the Artists in Embassy program. We returned the following year (by popular demand) as special guests of

the graduating art class of the University of San Francisco in Quito. Numerous other lecture and exhibition invitations followed.

In June 2001, Mount Vernon, New York, invited us to transform an old park, where winos congregated, into a successful community project. Characterized as one of the toughest areas in Mount Vernon, the corner of Fulton and Third was a dangerous area for children. Over a four-week period the Heidelberg Project recruited neighborhood children and senior citizens to redesign the area; today it is known as the Circle of Life Park, or, as the children affectionately call it, Hub Cap Park. The Heidelberg Project went beyond helping the community to reclaim the park by hiring some of those who once contributed to its bad reputation to help with the transformation. At the end of the residency and as a result of a newspaper story about the program, Mount Vernon subsequently hired one of the workers full time to care for the Circle of Life Park and other parks in the area.

Mount Vernon became a very special and magical place for Tyree and me. It felt good to work cooperatively with government officials and neighborhood residents. It was also the place where Tyree and I became engaged. At the end of July 2001, during the dedication of the newly restored Circle of Life Park, the mayor of Mount Vernon, Ernie Davis, announced that Tyree wanted to marry me in the park and that he had been asked by Tyree to perform the ceremony. Imagine my surprise! It was a thrilling time and, sure enough, Tyree and I returned to Mount Vernon in October 2001 for a wedding planned entirely by our new friends. Our intergenerational and interracial wedding party consisted of the very same people who helped us restore the park and was featured in the *New York Times* society page.

So there we were, a newly married couple receiving red-carpet treatment and toasted as trendsetters when we were on the road and rejected and frozen out by our own city and business community. It was enough to make one pack up and leave Detroit. Instead, we were encouraged by the goodwill extended to us and we went back to the drawing board.

We began acquiring property within the Heidelberg Project's borders and decided to concentrate on developing one house instead of trying to work on the entire two-block area at the same time. Hoping the dust had settled, we also initiated talks with the CDC in an attempt to find common ground, but these were unsuccessful. We also believed that it was

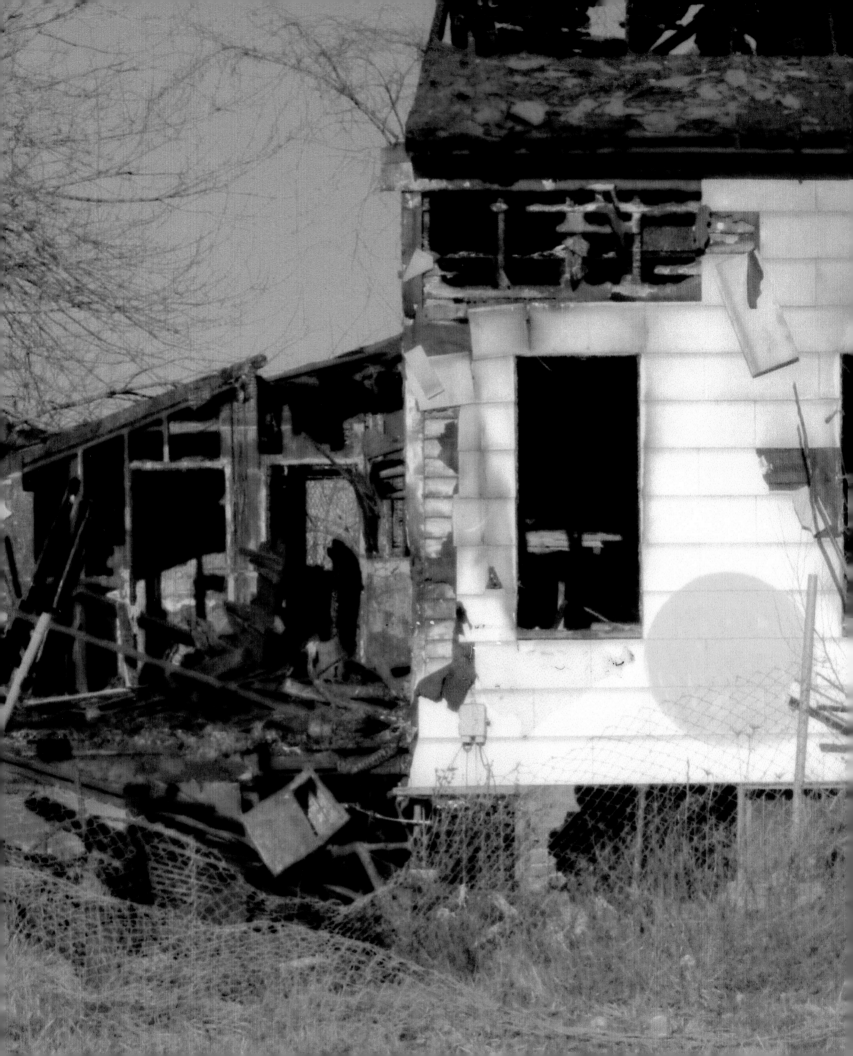

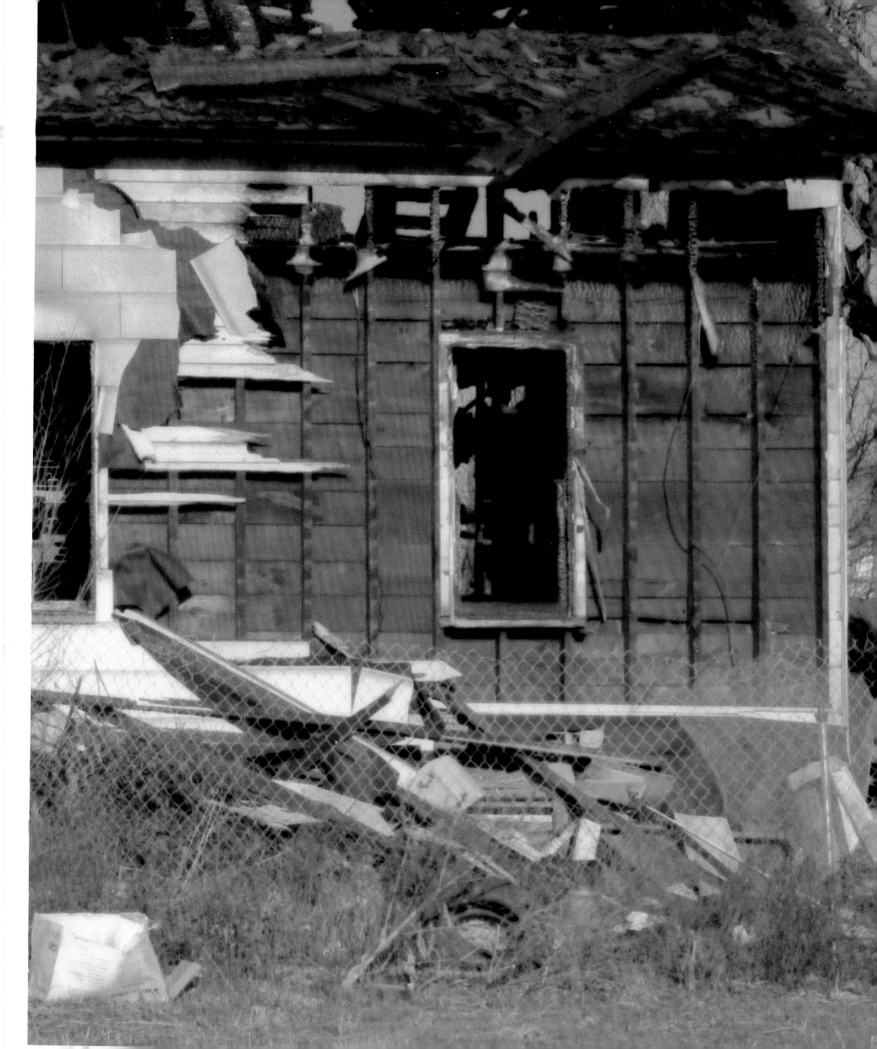

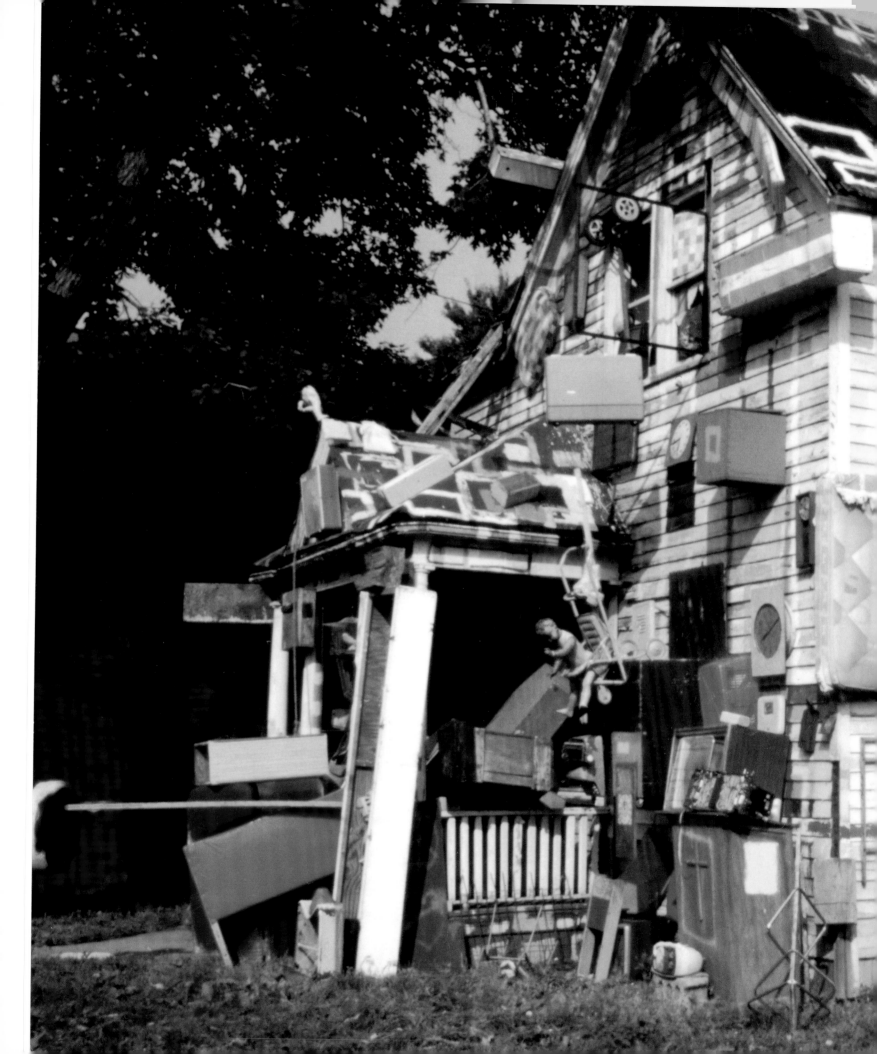

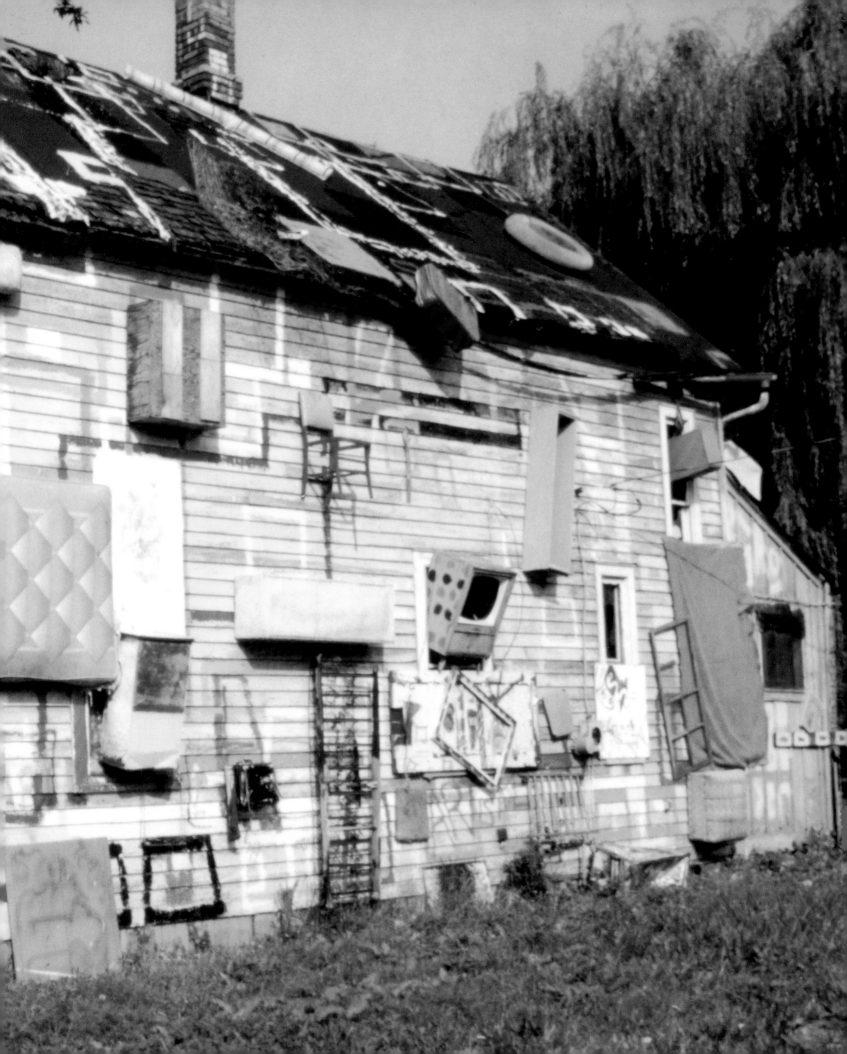

Acknowledgments

Tyree Guyton and Jenenne Whitfield would like to thank the contributors to this book. Without them, this project would not have been possible. ● We also extend a special thank-you to **Don and Hilda Vest** for their leadership in the Detroit arts community and their work toward creating and editing this book ● **Marion (Mame) Jackson** for her longtime friendship and support on numerous projects and especially for her guidance and counsel on this one ● **Terrence German** for his unyielding loyalty and for sifting through mounds of photos in his role of photo editor ● **Tom Porter and Kathleen Crispell** for their unyielding loyalty, love, and support ● **Gil Silverman** for his candor and support for the arts ● **The Heidelberg Project Board of Directors** ● **Sam Mackey** for his guiding spirit ● Thank you also to all of our photographers for their wonderful work over the years: **Elayne Gross, Harold Gross, Donna Terek, Jennifer Baross, Jack Johnson, Bill Sanders**. All the anonymous photographers who contributed to the Heidelberg Project archives ● Finally, thank you to **Wayne State University Press** and to anyone we may have unknowingly overlooked.

Grateful acknowledgment is made to the following, whose financial support helped make *Connecting the Dots* possible: ● *Principal Sponsors:* The Art Book Fund of Wayne State University Press, The Leonard and Harriette Simons Endowed Family Fund ● *Patrons:* Mary Lou Zieve, Dulcie and Norman Rosenfeld, Rochelle and Randy Forester, Oscar and Dede Feldman, John and Becky Booth ● *Donors:* Charles and Suzan Anderson

Full-page Photographs

© 2007 by Wayne State University Press, Detroit, Michigan 48201. All rights reserved.

No part of this book may be reproduced without formal permission. Manufactured in

the United States of America.

11 10 09 08 07 5 4 3 2 1

Library of Congress Cataloging-in-Publication Data

Connecting the dots : Tyree Guyton's Heidelberg Project.
 p. cm.
"A painted turtle book."
ISBN-13: 978-0-8143-3320-4 (hardcover : alk. paper)
ISBN-10: 0-8143-3320-6 (hardcover : alk. paper)
1. Heidelberg Project. 2. Community arts projects—Michigan—Detroit. 3. Guyton, Tyree,
1955— I. Heidelberg Project. II. Title: Tyree Guyton's Heidelberg Project.
NX180.A77C66 2007
709.774'34—dc22

2006033494

∞ The paper used in this publication meets the minimum requirements of the

American National Standard for Information Sciences—Permanence of Paper

for Printed Library Materials, ANSI Z39.48-1984.

Designed and typeset by Savitski Design, Ann Arbor, Michigan

Composed in Helvetica

Printed by University Lithoprinters, Ann Arbor, Michigan